"NOT TORRENTIAL RAIN,
BUT A CONSTANT MIST."

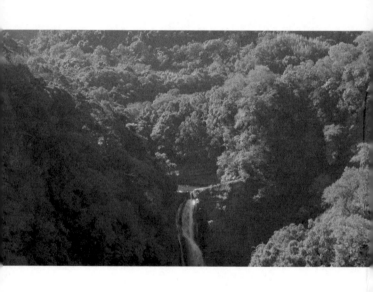

This page and previous page:
Tiffany Sia, stills from *The Sojourn*,
2023.

On and Off-Screen Imaginaries

Tiffany Sia

Primary Information

Contents

Foreword
Jean Ma

The writings in this volume bear a distinct time stamp: they were composed in the aftermath of the mass protests in Hong Kong known as the anti-ELAB protests, spurred by the institution of the Extradition Law Amendment Bill in March 2019 and dampened by the outbreak of COVID-19 in early 2020. As residents of the Hong Kong Special Administrative Region of China took to the streets in unprecedented numbers, images of their assembly exploded in the eye of global news media and on countless social media channels, propagated as spectacular photographic shots, live camera feeds, or incessant scrolls of information. The outpouring of public protest was followed by lockdown measures to limit the spreading pandemic, and then by a crackdown on civil unrest and political expression with the passage of the National Security Law in June 2020. Global media shifted its focus away from Hong Kong while arrests were made, news organizations dismantled, websites taken down, and recordings disappeared from video platforms. The signs of this history-making time vanished, leaving some traces behind.

In the following essays, Tiffany Sia carves out a vantage point at the glimmering edge of this frenzy and recoil of visibility.[1] The perspective telescopes in and out, drawing near to the front lines of street action and occupation at points, and taking a critical

distance at others, widening the frame to expose the paradoxes that beset the endeavor to capture an unfolding movement. These paradoxes multiply across time and space: if the criminalization of representation in the new juridical context renders "phantasms of dissent," in Sia's words, these phantasms find a counterpart in the ghosts of Cold War histories. Ghosts appear throughout this volume as figures of unrest, personified in the prisoners of war whose spirits haunt the police stations where they were incarcerated and tortured in occupied Hong Kong; in the laborers who left China in search of work abroad during waves of inter- and transpacific migration fueled by the debt-bondage system; or in the Vietnamese conception of ghosts as estranged ancestors, no longer bound to their communities.

In all of these instances, the ghost is a shadow presence in chronicles of the past, a keeper of untold and unaccounted memories, and a reminder of "those who have lost all social and political identity."[2] Between today's phantasms and yesterday's ghosts, and across plural sites—China, Japan, Vietnam, the Malay Peninsula, Hong Kong, Taiwan, the United States—stories and fragments beckon from beyond the frame drawn by means of legible periodizations, identities, and territories. More than only a response to the political present, *On and Off-Screen Imaginaries* is a meditation on the unfinished history of the Cold War, from its recessed beginnings to its interminable twilight. It layers multiple perspectives from a

host of peripheral places removed from the centers of national and colonial power, places that cannot be reduced to a single point on a map, and "locales whose specificities are blurred . . . such as contested territories, seized ports or battlefields, contact zones or port cities," as Sia writes in "No Place." Approached from the radical geography of such "elsewhere" sites, a fugitive history of the global Cold War edges into view.

What the moving image can contribute to the construction of alternative imaginaries is a question that arises across these various contexts. Writing about the wave of Hong Kong documentaries released in the direct aftermath of the anti-ELAB protests, Sia locates the force and innovation of these films in their abandonment of the conventions of advocacy, rejecting the goal of a clear overarching account of current events. Instead, they convey the embodied immediacy and durational intensity of maintaining, or failing to sustain, a stance of opposition—whether during the hours of a takeover of government offices, as in the Hong Kong Documentary Filmmakers' *Taking Back the Legislature* (2020); over multiple days of siege, as when students occupying the campus of Hong Kong Polytechnic University were trapped by a flank of riot police; or across generations and eras, as in the portraits of upheaval and dissent depicted in Chan Tze-woon's *Blue Island* (2022), which crisscross without coalescing into a singular history of Hong Kong.

In these productions, Sia identifies a "new documentary vernacular" of Hong Kong cinema. The films constitute a vital corrective to the portrayal of the anti-ELAB protests in mainstream news reportage, she writes, which reduces complex mobilizations to instantly legible, readily consumable, and quickly forgotten spectacles. If "crisis news is a genre film," as she observes in another context, it relies on a repository of well-worn visual clichés.[3] In contrast, this wave of filmmaking takes its impetus from difficult questions about the afterlife of political upheavals, the endurance of the needs and desires propelling mass movements, and the persistence of dreams deferred. The new documentary vernacular advances a compelling renewal of the project of political filmmaking in a moment defined by both the ubiquity and suppression of visual evidence.

In delineating the strategies and stakes of contemporary Hong Kong cinema, Sia brings to the field of film criticism some of the most powerful writing and sharpest analysis it has seen in recent years. Her critique is honed by the moving currents of a continually developing situation. Filtered through the nuances of this situation, and distilled by its urgency, theoretical reflection on the capacities of cinema becomes vivid and takes flesh. Thought crystallizes in the form of indelible figures and concentrated gestures that recur throughout her writing, such as "flipping the coin of visibility and invisibility." The turning of the coin that cannot rest describes

the balancing act demanded of the filmmaker hemmed in by visibility on the one side—the profusion of images not only documenting the protests, but also operationalized by both activists and police as a tool of mobilization and punishment; and invisibility on the other side—the restrictions and censorship imposed by the National Security Law and further complicated by vague language, changing standards of enforcement, and shifting red lines. Just as significant as what the new documentary vernacular brings to the screen is what it does not show; omissions, blurred faces, and anonymized credits carry the weight of meaning. These find a counterpart in the redaction bars that punctuate Sia's writings, such as "Handbook of Feelings," and the broken hyperlinks cited among their sources. The coin turns again at the point of reception: to recognize the achievement of this wave of filmmaking is also to register the irony that they may only be exhibited outside of their place of origin, far from the locations where they were shot. Abroad, they circulate along with the films of yesterday, which command fixation as products of a lost golden age of Hong Kong filmmaking. Nostalgic visions of the *déjà disparu* described by Ackbar Abbas now represent Hong Kong's most durable cinematic export, and, writing in "Elliptical Returns," Sia wryly acknowledges the result of "a city calcified in time." But in Hong Kong today, a new documentary vernacular of social engagement takes shape as an exilic, fugitive cinema. In describing

its formation, Sia offers a profound meditation on the politics of moving images at the present juncture of accelerating geopolitical forces. What are the stakes of filmmaking and spectatorship as they reveal themselves in this place and time? What does the survival of cinema hold out for the survival of political ideals?

Such concerns preoccupy Sia not only as a writer, but also as a filmmaker and artist, signaled in the titles of her moving image works, and developed across layers and concatenations of image, sound, and text. Her 2022 short film *What Rules the Invisible* approaches the titular question via the incongruence between found images and inherited words, pushing to an extreme cinema's capacity to "hold tension between what is shown and what is suggested"[4] as it conjures a colonial era that is also a familial past. Travelogue footage of Hong Kong under British rule, depicting natural landscapes and scenes of life amid colonial modernity from an outsider's perspective, alternates with text intertitles citing anecdotes from the same time passed down by Sia's mother. These family anecdotes compose a reverse perspective to that of the travelogue images, as they tell of what transpires behind the walls of the police stations in their midst, with stories of incarceration, torture, and restless ghosts. The film's structure evokes the "double gaze" that Sia identifies in the photography of An-My Lê in "No Place." For the two artists, the negotiation of

media memories of Hong Kong and Vietnam necessitates a puncturing of the Western gaze that frames the visual imaginary of the Cold War.

Sia likewise invokes an underside that lies beyond the scope of visual evidence in connection to her 2020 work *Never Rest/Unrest*. Shot with a mobile phone during the height of the anti-ELAB protests, the short film conveys the day-to-day experience of living through political storms. Amid shattering events of unrest and the acceleration of history, ordinary life continues in its banality, and disorientation seeps slowly into awareness. The incommensurable distance between these disparate scales, which the film inhabits, poses a representational problem: "You could say that the crisis of war is defined by images of combat. But what about a legal crisis? What about a crisis of sovereignty, or a crisis of the rule of law? These are a challenge to image making; they evade capture."[5]

For Sia, the metaphor of the turning coin describes a critical lens, a practical methodology, as well as an ethos of engagement. In "Toward the Invisible," written in response to an invitation to speak at a symposium about Asian American art, Sia resists the representational compact embedded in the category itself. If minoritarian politics are frequently taken up as a quest for representational agency, this quest is accompanied by the perils of overreliance on institutional legitimation and appeals to a shared identity or a common language of forms. Meanwhile,

the effects of erasure continue to compound in the present—as evidenced by multiculturalism's pact with the ideology of American exceptionalism, which "obscures" Indigenous histories and undermines claims to sovereignty. In mind of the contradicting demands that shape the project of political art, Sia offers up a blank image in an attempt to "summon a political imagination toward the unseeable, the un-archived, the inconvenient, or the contradictory." Against the consolations of visibility, and in alliance with other American artists who resist the promises of legibility, she pushes toward an alternative formulation by way of an aesthetics of opacity, refusal, and negativity, the latter defined by Theodor Adorno as a project of "[summoning] into appearance what appearance otherwise obstructs."[6] The turn of the coin traces the dialectical turns of her thinking.

Sia's own films bear a relation to the new Hong Kong cinema about which she writes. Works like *Never Rest/Unrest* share in the status of a vernacular cinema that is also an exilic cinema, marked by limited circulation and territorial displacement. Sia's recent departure from Hong Kong—a place of birth, of return, and of her beginnings as an artist and writer—shadows the writings in this volume (as "Handbook of Feelings" discusses explicitly). The perspective that telescopes between "close and distant studies" indexes this relocation, itself part of a larger exodus of artists, journalists, teachers, and others taking place as a

result of the ongoing clampdown. Winding through the essays are reflections of a shifting relation to a place left behind and attempts to measure distance by way of the distorting surface of a rearview mirror. Hong Kong is both closer and more removed than it appears; it cannot be relied upon to anchor a claim to identity or a story of origin. Discussing with friends the events that brought her family to Hong Kong, Sia discovers in them a story of "no place," a story that "offer[s] no direction for root-seeking, nothing to be nostalgic for, no territory to return to." If her current situation echoes a longer history of arrivals and departures—in which Hong Kong has served as a place of refuge, a port of transfer, or a temporary abode—this history does not add up. It amounts less to a straightforward genealogy than to a densely knotted cluster of passages, many lacking clear beginnings, folded over continual waves of migration rippling from political conflict and privation.

The negative formulation of "no place" recurs throughout the essays as another charged gesture, conveying dispossession with respect to place as well as image. As a formulation premised upon lack, "no place" calls to mind long-standing characterizations of Hong Kong as a "floating city" or a "space of disappearance," consigned to provisionality, conditionality, and political uncertainty.[7] If the "no place" is missing a history of its own, then the phrase must also refer to the many other "elsewhere sites" of the Cold War. In these sites—situated "in the interstices

of empire" and amid the fallout of struggles between greater powers—counternarratives of history incubate. Yet these counternarratives "require alternative archives"; citing Thy Phu, Sia notes that they call for "resources that are not easily accessible or interpretable."[8] Stories of flight like her family's—along with those of others fleeing violence in China, Vietnam, and other zones of conflict—often endure without the benefit of photographic evidence or archival verification. And "no place" can also mean locales lacking terrestrial reality, existing only in memory, imagination, or fantasy. The stunning landscapes composed by the émigré director King Hu in the martial arts films through which he rose to fame are unforgettable yet doubly removed from actuality. Searching for images of a heroic, mythological China and chasing after the romance of an inaccessible homeland, Hu traveled to South Korea and Taiwan with his crew. In these elsewheres, he realized his imagination of the past and resurrected a misty landscape of "rivers and lakes."[9]

Hu's project finds an echo in a comment by An-My Lê: "Instead of seeking the real, I began making photographs that use the real to ground the imaginary."[10] Notwithstanding the gulf of time and sensibility separating the filmmaker and the photographer, what Sia observes in Lê's photos might just as well apply to Hu's films: "The fantasy of an 'elsewhere' also becomes a fantasy of the 'here,' as the two begin to merge." This overlaying continues in Sia's

2023 film *The Sojourn*, in which she visits the locations in Taiwan where King Hu shot his 1967 breakthrough hit *Dragon Inn*. Sia and her crew drive up and down mountain roads in a search for misty landscapes that retraces the twisting paths of exilic cinematic memory. Colossal peaks melt into pools of milky vapor. The shadow of "no place" alights upon the present. In this endeavor to reanimate Hu's filmic imaginary, perhaps Sia grapples with her own question: "What to seek out of the past to tell the present?" Not a root to cling to, but an elsewhere as a deterritorialized horizon of belonging.

Notes

1. The phrase "frenzy of the visible" comes from Jean-Louis Comolli, "Machines of the Visible," in *The Cinematic Apparatus*, ed. Teresa de Lauretis and Stephen Heath (New York: St. Martin's Press, 1980), 122.

2. Avery Gordon, *Ghostly Matters: Haunting and the Sociological Imagination* (Minneapolis: University of Minnesota Press, 2008), 80.

3. Tiffany Sia, *Too Salty Too Wet* (Hong Kong: Speculative Place Press, 2020), 24.

4. Sky Hopinka, Tiffany Sia, and Emma Wolukau-Wanambwa, "Any Knowledge We Produce Can Be Used Against Us," *Art in America*, May 17, 2022, artnews.com/art-in-america/interviews/anticolonial-film-sky-hopinka-tiffany-sia-emma-wolukau-wanambwa-1234629034/.

5. Tiffany Sia, "Never Rest/Unrest: Emerging Time," in *Signals: How Video Transformed the World*, ed. Stuart Comer and Michelle Kuo (New York: Museum of Modern Art, 2023), 106.

6. Theodor W. Adorno, *Aesthetic Theory*, trans. and ed. Robert Hullot-Kentor (Minneapolis: University of Minnesota Press, 1997), 105.

7. See Xi Xi, *Marvels of a Floating City*, ed. Eva Hung (Hong Kong: Renditions Paperbacks, 1999) and Ackbar Abbas, *Hong Kong: Culture and the Politics of Disappearance* (Minneapolis: University of Minnesota Press, 1997).

8. Thy Phu, *Warring Visions: Photography and Vietnam* (Durham, NC: Duke University Press, 2022), 49.

9. Historic martial arts films are distinguished by their setting in the mythical realm of *jianghu*, which is literally translated as "rivers and lakes."

10. An-My Lê, *Small Wars* (New York: Aperture, 2005), 119.

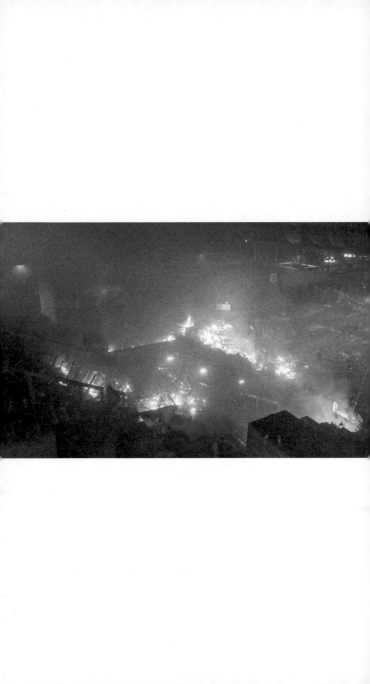

This page: Tiffany Sia, still from
What Rules the Invisible, 2022.

Previous page: Hong Kong
Documentary Filmmakers, still from
Inside the Red Brick Wall, 2020.

Handbook of Feelings

In October 2020 in Hong Kong, three months after the passing of the National Security Law, I lectured at a film class at ███ University. I opened the lecture with Julio García Espinosa's "For an Imperfect Cinema," a seminal essay written in 1969 that argues for a politics of filmmaking that subverts the technically perfect and pleads for a cinema that is urgent and process-driven. Showing a series of film excerpts from Sky Hopinka's *Dislocation Blues* (2017), Adam Khalil, Zack Khalil, and Jackson Polys's *The Violence of a Civilization without Secrets* (2017), tooth's *moyah pravda newsreel* (2011), and Trinh T. Minh-ha's *Reassemblage* (1982), I encouraged the students to see beyond the traditional limitations of documentary. I wanted them to realize they could make a film with a small budget and argued that aesthetic goals shouldn't supplant urgent storytelling or forsake ethics. The professor, ██, a friend, was familiar with my work and expected the tone and ethos of my references to be political in nature, but still, I hesitated before showing them my own short film *Never Rest/ Unrest* (2020), made during the 2019 protests in Hong Kong. Taking up the mantle of Espinosa's manifesto, the twenty-eight-minute-long film, shot on an iPhone, presents a diaristic view of the Hong Kong protests in a 16:9 vertical aspect ratio. The experimental short depicts moments of in-betweenness and waiting that pervaded the relentless duration of the insurgency, sometimes in the heart of direct action—a challenge to the spectacle and clichés of

19 Handbook of Feelings

crisis reportage and documentary. Three school administrators were sitting in on the class. When the images of masked schoolchildren in uniform assembling at a mall flashed on-screen, their chants filling the room, the students audibly held their breath. I could feel them shifting in their seats, squirming. I watched ███'s face for anchoring. My eyes darted over to the school administrators sitting nearby: their expressions were blank.

A few months later, when I caught up with my friend ███ again for dinner, he said, "I think the students really enjoyed your film. It was really meaningful to them." It was the first time my film had been screened publicly in Hong Kong, I told him. "I think they were shocked that they were seeing your film in a classroom setting," he said. "Actually, I have to tell you a story." He recounted that, a few months after my lecture, on a bus ride, he was sitting next to one of the administrators present at the lecture. The administrator asked ███, "How is that filmmaker? How is she doing?" ███ paused for a moment, but then it dawned on him what the administrator really meant. He was trying to ask about my safety and whether I was still in Hong Kong. ███ attempted to answer the question with improvised innuendos. When ███ relayed the story to me, he laughed nervously. There was a bit of theatricality to it, he explained. Absurdity. "It seems that new social norms are being constructed. New norms in how we communicate. Anyway, I don't think you could

screen your film at the university now." Since my guest lecture, surveillance cameras, including one that looms over my friend's desk, have been installed throughout the faculty offices; worries grow among professors that they will be asked to sign an oath of allegiance before long. A rumor has spread that no fewer than a thousand workers were hired by the Liaison Office—the official arm of the Chinese Central People's Government in Hong Kong—just to observe the education sector.

As the confrontations between protesters and police are no longer seen in the streets, the front lines of conflict have materialized in a different form—one less able to sustain international news attention with spectacles of unrest. These new sites of assault emerge as exhaustive missives: landmark rulings marking the new limits of speech, social media posts written by artists and activists announcing their exile, lists of new arrests, statements by disbanded unions, and new ordinances such as an exit ban giving immigration officers what some argue amounts to "unfettered power" to prevent anyone from leaving Hong Kong.[1] The remaking of the city unfolds as a gradual erosion. "It's actually happening quite fast," my friend ███ said recently. "Every week it's something. And sometimes daily." Every quarter brings a seismic headline: forty-seven pro-democracy politicians and activists arrested in a single day; the newspaper *Apple Daily* raided and pressured into folding; the teachers' union, which

had a membership of ninety-five thousand, disbanded under political threat. And yet there is another, less visible front line of the crackdown: the bureaucratic process of censorship, which materializes in the regulation of public spaces and licenses, and the films and artworks the public does not hear about that are never screened or exhibited. You cannot know about what you cannot see.

Established in British colonial Hong Kong, the Office for Film, Newspaper and Article Administration (OFNAA) is tasked with rating films, and it must grant permission before a work may be exhibited publicly. It is a de facto censor: freelance workers vet all films and videos shown in cinemas and public institutions to gauge their political sensitivity. In June 2021, the OFNAA published "Film Censorship Guidelines for Censors," a legal toolbox for the vetting of screenings in accordance with the National Security Law that employs language amenable to broad interpretation. "When considering a film as a whole and its effects on the viewers," reads a representative passage, "the censor should have regard to his duties to prevent and suppress acts or activities endangering national security." Applying particularly to documentaries—though refusing to name them as such—the guidelines spotlight films deemed a danger to national security that "purport to be a documentary or purport to report on or reenact real events with immediate connection to the circumstances in Hong Kong" and caution

that such work "necessitates an even more careful consideration of its contents by the censor."[2] The same day the guidelines were released, Hong Kong's 15th Fresh Wave International Short Film Festival canceled a screening of *Far From Home* (2021), a fictional short directed by Mok Kwan-ling that centers on the protests, citing OFNAA's failure to issue either a certificate of approval or refusal before the scheduled event.[3]

Inside the Red Brick Wall, a feature-length film on the 2019 siege of Hong Kong Polytechnic University, and the short *Taking Back the Legislature*, on the storming of the Legislative Council by protesters, were released in 2020 by a group identifying itself as Hong Kong Documentary Filmmakers. The release of *Inside the Red Brick Wall* triggered criticism by the government- and state-owned newspapers, thereby illuminating the various mechanisms that define and regulate the licit. Both films were shown as a double feature at Ying E Chi cinema in September 2020. A warning card appeared at the beginning of *Inside the Red Brick Wall*, cautioning, "Some of those depictions or acts may constitute criminal offences under prevailing laws. Some of the contents of or commentaries in the film may be unverified or misleading." The OFNAA had mandated that the documentarians use such a disclaimer at the beginning of the film, and yet, even after giving it a Category III rating—the equivalent of an X rating—the OFNAA asked the documentarians

to keep the demand for the warning card a secret.[4] The news was leaked anyway, and a rumor spread that the screening DVD sent to the OFNAA had been "returned broken in pieces."[5]

The fallout implicated various art and film organizations in the city. Ying E Chi cinema became a target of political retaliation. First it was attacked by state-owned Chinese newspapers, then its funding was abruptly cut by the Hong Kong Arts Development Council, which is funded by the city government. *Ta Kung Pao*, a local pro-Beijing newspaper, published an opinion article criticizing the Arts Development Council for "funding black violence movies,"[6] the term "black" being a direct translation from Chinese signifying something sinister and criminal. An illustration featured alongside the piece depicted a reel of celluloid unfurling across the page, secreting black sludge.[7] Citing "personal reasons," three members of the council—the artist Chris Chan Kam-shing, the songwriter Adrian Chow Pok-yin, and the theater director Indy Lee Chun-leung— resigned, though it was clear they had been forced out by political pressure. All three had become targets of criticism by multiple state-owned Chinese newspapers, which referred to them as "troublemakers" and "anti-government figures." In addition, Chan was doxxed, his personal details published.

The vagueness of the National Security Law leaves the legality of films and artworks open to interpretation, and the uncertainty over the

consequences of violating the law only further underlines its vagueness. Any artist publishing, screening, or circulating an arguably politically sensitive work risks setting off the state's invisible trip wire. Even the act of circulating material potentially in violation of the law implicates all parties involved. The case of *Inside the Red Brick Wall* illuminates the circuits and various arms of the state that censor, intimidate, and threaten artists and filmmakers through both legal and extralegal means. State newspapers, for example, act as searchlights illuminating new targets. In a time of so many unknowns that invite endless speculation and paranoia about political threats, receiving unwanted press is one definitive way of knowing that you are on the authorities' watch list and that, at the very least, you should be prepared for the consequences to come.

Still, the locations of such trip wires are unpredictable. When Kiwi Chow premiered *Revolution of Our Times* (2021) at the Cannes Film Festival in July 2021 under his own name, the Hong Kong independent-film world was surprised that he chose not to release it anonymously. In interviews, Chow has explained that he is ready for the potential consequences of releasing such a film and stated that he won't be leaving Hong Kong despite the risk. Chow's decision to go public could be read as living out the raison d'être of his evocatively titled vignette *Self-Immolator*, in the multidirector film *Ten Years* (2015). The Cannes premiere of *Revolution of Our*

Times coincided with a landmark ruling that deemed the eponymous phrase "revolution of our times" tantamount to inciting secession.[8] The international press described the last-minute programming announcement as potentially forcing a diplomatic "situation," but local politicians in Hong Kong and state-owned newspapers were eerily, perhaps even strategically, silent about it. *Revolution of Our Times* has only been publicly screened outside of Hong Kong. Yet both the National Security Law and a newly passed film censorship ordinance leave room for retroactively criminalizing acts—and even for laws to apply extraterritorially, allowing them to extend promiscuously through time and space, far beyond Hong Kong or any Chinese territory.

Even films that get past local censors might still be deemed a breach of the National Security Law. Clement Leung Cheuk-man, the permanent secretary for commerce and economic development, has warned of this potential dissonance, adding that film censors—who are, after all, civil servants—will be given national security training. While Hong Kong's censors have government affiliation, they are not functionally part of the Office for Safeguarding National Security of the Central People's Government in Hong Kong. Nor are they part of the Liaison Office. By hiding behind vague legal language and a complex web of accountability for regulating speech, one could argue, the government leaves both the public and censors to guess where the line

separating safe and unsafe speech is. In this way, many fear that organizations such as the OFNAA will end up producing yet another line, invisible to the public and drawn by self-censorship, in order to evade their own liability.

The Office for Film, Newspaper and Article Administration, less known by the public, also performs background checks on artists and filmmakers producing film or video that is exhibited in cinemas or public art institutions. ██, a friend, told me bluntly, "You couldn't have done the show you did at Artists Space at an institution here," referring to my solo show *Slippery When Wet*, which was exhibited at Artists Space in New York for the first few months of 2021 both online and at its 11 Cortlandt Alley space. The show presented paper-based works, sculptures, new-media installations, and films, and its theme centered on developing a "wet ontology" of Hong Kong—a city in a process of ongoing and violent transfiguration—using ink, tears, leaks, and logistical flows. ██ continued, "And if they did a background check on you, it would be very, very interesting." Another friend, █, surmised, "If artists are censored just because they've posted about the 2019 protests, most Hong Kong artists wouldn't be able to be shown in local institutions or venues anymore." Many worried that for this reason censors were taking an overzealous approach. It seems that the vagueness of the law allows the state to produce the social conditions of fear and paranoia that

encourage both organizations and individuals to proactively redact, sanitize, and/or expurgate works of art.

A few months after the promulgation of the National Security Law, I managed to work with a local printer to produce my book *Too Salty Too Wet* 更咸更濕, a follow-up to the zine I published in June 2019, *Salty Wet* 咸濕, its title a playfully bad translation of the Cantonese word for "perverse." Wrapped in a Mylar jacket, the sequel recounted my experience of being a witness to and living through the encounter with police violence, inserting a reading of the violent history of Hong Kong into its "centerfold." I did my due diligence, finding printers who were in the "yellow economic circle," i.e., who were rumored to be sympathetic to the protests. Some friends even suggested that I print it with pornographers. During discussions outlining the requirements and specs of the job, the printer I approached asked, "What is the nature of this book you're printing? A novel?" I paused, nervous that, even if I had done a background check on him, I couldn't be sure if this individual I was speaking to was sympathetic. "It's a book on history and personal essays," I explained in Cantonese. Divining potentially sensitive contents, the printer told me he would have to approve the text before accepting the job and share it with two other colleagues to vet the book and make sure it was not in violation of the law. "You understand, this is what we have to do now to avoid

doing something illegal." I came away from the meeting extremely uneasy, doubting that I had chosen the right printer. I had already written the book with redactions, even opening it with a facetious disclaimer to the effect that it may or may not be fiction and replacing protest slogans with black redaction bars. Later that day, I sent him the PDF. It would take a week before they could give me an answer. Over the phone, I was told that the binder, who was based in mainland China, had refused within hours of receiving the PDF, based on its contents. The printer explained that the binder, a subcontracted vendor, didn't want to be liable if the shipment was seized at the Shenzhen border. Still, he told me that they could print it in Hong Kong, but instead of it being thread-bound as per my original plan, the book would have to be perfect-bound with thermal glue. Weeks into production, he sent me a short video over WhatsApp. It showed printed pages being sorted by a large machine, and as the video panned across sorted reams of paper on a belt, there, barely visible, was a small cartoon sticker depicting ████ on the side of the machine.

Shortly after the passage of the National Security Law, public art institutions hired legal teams to help assess their risk. Popular protest phrases, such as "Free Hong Kong, revolution of our times," "No riot, only tyranny," and "Corrupt cops, may your whole family die," were widely understood to be banned—one could be arrested just for uttering

these phrases on the street. The consequences for employing other expressions were less clear. In preparation for a reading and performance, I was told that the institution hosting it had been advised by its legal team that acts of speech that may be interpreted to promote or express "secession," "subversion," "terrorism," and "collusion" were to be avoided. "I'm not even sure what that means," I said. It was the responsibility of the institution to avoid hosting an illegal event. "If there is anything punishable by law during a performance, the venue should stop it," I was told by ▇▇. I was friends with the programmer, so I was sympathetic to the position they were in. They continued, "If we find that there's an issue, we'll say that we're experiencing technical difficulties." The term "technical difficulties," cited as a reason for a canceled event, is widely understood in mainland China as a euphemism for censorship.[9] Some say that Hong Kong is becoming more like the mainland and that Hong Kong artists have much to learn from artists there. Others argue that for the next several years, Hong Kong artists will face much greater scrutiny than mainland artists. The new censorship law, which expands on the National Security Law and which was released while I was writing this piece, specifies three years in prison as punishment for exhibiting banned films in Hong Kong—a more severe punishment than in the mainland. I was still uncertain where the red line was for my reading/performance, so I kept pushing for more

legal insight. The programmer confessed, "The line between advocacy and documentary is very fine. It turns out that the law is quite broad, but the lawyer seemed confident. As long as you don't violate the law, he said, it's fine."

In the end, no "technical difficulties" interrupted my reading, though I felt as though I was shadowboxing, having to weave and navigate around an invisible opponent in the form of codes and sanctions. Later, a rumor spread that Hong Kong gallery directors had been invited to a private dinner with Chief Executive Carrie Lam, who advised them on the limits of the law and assured them that the Liaison Office would only go after exceptional cases. "And they trust Carrie Lam?" I asked. "I don't know where the line is anymore," another friend, ███, confided. "I used to think I knew, but I have no idea anymore." When the rule of law is dead, perhaps it is better to go to clairvoyants than lawyers, I joked. How can one be confident in the value of legal advice at a time like this? Even some who interpreted the National Security Law as merely an anti-protest law were wrong. Such a reading was an extremely limited interpretation that underestimated its powers; in practice, the law would be much more comprehensive and far-reaching. And one must also account for the use of extralegal political tools—harassment, surveillance, intimidation by state press, and doxxing.

Political pressure also appears in the form of bureaucratic obstacles. Galleries have been pressured

to apply for Temporary Places of Public Entertainment licenses, which are impossible to obtain for art institutions operating out of industrial spaces, as many do. This, some fear, could be a way for police to crack down on such spaces via registration technicalities, even COVID-19 regulations. In June 2021, Parallel Space, an art venue operating in Sham Shui Po, was raided twice by police and accused of operating without a license by the Food and Environmental Hygiene Department. The police photographed the works on display after receiving a complaint that they contained "seditious" content.[10] A national security hotline was launched by police, drawing hundreds of thousands of tips.[11] The regulation of lawful speech implies a system of fear, but loyalists and nationalists are enthusiastic about taking part and are incentivized by political ambition. A culture of informants is only just developing, and lawmakers in Hong Kong, eager to please Beijing, have gone on smear campaigns of their own. At the Legislative Council, pro-Beijing lawmaker and New People's Party chairman Eunice Yung lambasted West Kowloon Cultural District's M+ museum, claiming that its inaugural and upcoming shows were causing "great concern" and asking, "Would the art pieces to be displayed there breach the so-called red line? With the National Security Law in place, we have to safeguard national security." Spotlighting museum exhibitions and public institutions, Carrie Lam responded by saying that

This page and previous page:
Tiffany Sia, stills from *What Rules the Invisible*, 2022.

authorities will be "on full alert" to make sure museum exhibitions are not undermining national security.[12]

Speculating about the existence of an invisible class of political targets—or, at the very least, of people of special interest to the state and subject to extra surveillance—invites panic. It is easy to overthink things. Some people, including my father, who no longer lives in Hong Kong, believe that what they've posted on Facebook, Twitter, and other personal social media accounts would prevent them from being allowed back. This is an exaggeration, at least for now. (Since the original publication of this text in 2022, the situation has changed. A Hong Kong student was arrested in April 2023 over comments she made on social media while studying in Japan.) Holding an opinion involves a different level of risk than being implicated in organizing in political organizations or trade unions, or being the author of or participating in the production of politically sensitive material. The crackdown requires that one deploy specificity as an antidote to fear and paranoia. Rather than simple alarmism, this environment demands careful analysis when determining where the red line is and what actions are still possible. Increasingly, artists become anonymous or release works under pseudonyms. Given the collapsing infrastructure for artists in the form of disappearing university jobs, denied visas, and imperiled government funding, how can they endure? While many are leaving, many

are also staying. Some cannot afford to leave, and some cannot leave their elderly parents behind. Others have simply chosen to stay. Some even want to stay to see these events through, even if it means they risk having to leave suddenly, overnight; they want to see what's still possible. Others are prepared to face imprisonment. In the midst of all this is the hope that an underground will flourish, but when artists and filmmakers disperse, adapt to new methods of circulation, and invent new forms of survival, there is an impossible paradox: the underground needs the public to engage with it, but secrecy enables its survival. Is it possible to sustain hiding in plain sight?

"I stopped reading the news at the end of 2020," someone told me when I had them over for dinner. "It was too much for me. But anyway, are you really worried? There are certain people whom the government has targeted, but they are few. It's not that bad." Remarking on the banning of the June 4 vigil in Hong Kong, journalist Louisa Lim remarked, "If the vigil is banned forever, we will all become like the Tiananmen Mothers. Those who remember will no longer be able to remember *en masse*. When you atomize that, so that people can only remember secretly and silently and in small groups, I think it's a huge loss."[13] When remembering can no longer be a collective activity, it is the responsibility of individuals to do so on their own. Yet those continuing to keep resistance alive, whether in secrecy, anonymity, or through more obscure

forms, become more exposed. Threat is experienced unevenly. Describing a man pacing in front of the glass doors of her office, my friend confided in me that she might have been followed shortly after it was announced that government funding was pulled from her ■ production company. The entropy of civil society atomizes experience, even after a prolonged swell of collectivity in protest. "Mutual trust," my friend ■ observed, "is now untenable in social interaction."

By August 2022, another 113,000 residents reportedly left Hong Kong. Making up only 1.5 percent of the population, this segment accounted for almost two thousand nurses, or 6.5 percent of the total number of nurses, as well as a similar proportion of teachers and doctors. About 40 percent of teachers are projected to retire or resign early. Before 1997, eight hundred thousand people emigrated from Hong Kong in anticipation of the handover. After 1997, five hundred thousand of those returned with foreign passports, making up the "return diaspora."[14] Given that it depends on the future political climate in Hong Kong, predicting whether another return diaspora will form is difficult. From the safety of exile in Taiwan, the artist Kacey Wong recounted to the press his departure from Hong Kong airport, during which a group of extra immigration officers, "spread out as if they were playing American football," were called to stand at the gate to watch "everyone who was boarding for a last-minute tackle."[15] Leaving Hong

Kong at this time forces one to confront the possibility that a return may be impossible, given whatever one is on record as having done or being likely to do. The term "bottom line" is often used to state a personal limit for staying in Hong Kong. For some, the bottom line is having to take an oath at one's job. For others, it's seeing people like themselves in danger—a catalyst for determining that a fundamental paradigm shift has taken place. While I too looked to other artists and filmmakers in Hong Kong to gauge my own safety—people who made work under their own names and were politically vocal—I became unnerved when I realized that some of these people were using me as *their* gauge. I felt reasonably confident that I was safe, but the psychological game of locating the parameters of potential exposure or even heightened surveillance produced paranoia that felt increasingly isolating. And when Kacey Wong, an artist whose departure was for some in the arts community their bottom line, announced his exile, what then? "I feel like I've kept shifting my bottom line," my friend ■ confessed. If we are to understand ourselves as living inside of history, how do we understand the nature of the times we live in now? Knowing what time in history we are living through right now can only be speculative, and in Hong Kong, questions remain regarding the true gravity of the threat: When will the firewall go up? When will there be no resistance to the argument that universities are no longer "free" places? When will it be time to flee?

For the past two months, I've been talking to my parents less than usual. Phone calls often led to warnings from them and questions about whether I had seen the news. I could tell them about all the other people I know who are more politically exposed than I am, but they don't care. I could tell them I haven't had any of the warning signs that more well-known and more visible artists have experienced. I haven't been followed. I haven't been written about by a state newspaper. I could tell them that my work is too abstract or oblique in its approach. Once, when I tried to explain this, my mother said, "They are intentionally unpredictable. You've written a book. They're particularly sensitive about printed materials." Sometimes my mother says, "You are very brave." But in a subsequent phone call, the sentiment abruptly shifts to another tone: "You are very naive." For my parents—my father's family fled from Shanghai to Hong Kong as political refugees—the line between leaving early and leaving too late is a knife's edge. Attachment to a place when it defies pragmatism has proven fatal historically, and my parents fear an unrecoverable miscalculation on my part.

Every summer since 2019 has been the hottest one on record. Speaking about the unrelenting heat with a woman who owns a small shop a few doors down from where I live, I tried to stand out of the way of bicycle traffic in the village alleyways as she lamented, "It feels like a typhoon is about to

come, but it never fully releases." The intense and unprecedented heat, a sign of broader climate change, of course, is only secondary to the news of crackdowns unfolding every day. The air envelops you when you step out of the house. Your body feels immediately heavy from the humidity. Those jailed in Hong Kong, many of them in Stanley Prison on the south side of Hong Kong Island,[16] sit in cells and facilities that are particularly poor at mitigating this intense heat. In May 2021, a "hot-weather petition" with one hundred thousand signatures urged better welfare for prisoners, including more frequent showers, the provision of cold water, and better ventilation.[17] Jails are almost the only places where air conditioning is absent in Hong Kong, even as more people are imprisoned for political crimes. Where protection against subtropical heat is absent, from the coffin-sized subdivided flats where some of the poorest in the city live[18] to the sleeping quarters of migrant domestic helpers,[19] the abyssal line of the marginal communities that make up the city becomes visible.

For people with any political exposure, it is reasonable to speculate that you are on some kind of list, and also, equally importantly, that the list is ranked in terms of priority. You know the extent of your political exposure, even if your friends may not, and you look to the news to see the people facing the front lines of the crackdown as markers of risk. A personal checklist of threat can be

summarized as follows: (1) what news outlets you've been quoted in and what you've been on record as saying; (2) what you've published; (3) the nature of the articles, books, texts, or films you've released, the size of the platforms these materials were distributed through or released on, and whether these venues were local; (4) what groups you may be part of and whether that is on record; (5) what you've been documented on film or in writing as doing; (6) whether you've been captured on video in certain actions; (7) what content you've published has gone viral and whether it has been reposted by state media; (8) whether you've been followed; (9) whether you've been arrested, and if at a protest site, under what pretense could you face rearrest; (10) whether state media have written about your work; (11) if you were quoted in the *New York Times* or the *Washington Post*, how politically sensitive were the things you said; (12) whether you've received threatening messages from individuals or immigration authorities; (13) whether you were in particularly significant protest actions, such as the occupation of the Legislative Council or the siege of Hong Kong Polytechnic University; (14) what your social media presence is like; (15) whether you run a public space or organization. Some have been careful this whole time. Some are backtracking and saying less. You feel a spasm after each crackdown, especially when someone of a similar occupation or profile becomes a political target or announces their exile. As an

enigmatic system of threat grows, it becomes clear that this is a time of many unknowns.

Meanwhile, a well-heeled and hypervisible side of Hong Kong is intent on sustaining its image as Asia's World City, as the official slogan goes. "Nothing has dented confidence here," insists Francis Belin, Asia Pacific president of Christie's, upon announcing a new Asia headquarters in the city.[20] Concurrently, a new contemporary art museum, West Kowloon District's M+, is slated to open in the fall,[21] and Art Basel Hong Kong just entered its eighth year. Senior Beijing officials have urged Hong Kong's government to continue to make efforts to improve its international image in arts and culture, especially with the intent of keeping up with competing cities such as Seoul. In a piece in the *South China Morning Post* interviewing expats on their views on Hong Kong's political outlook, one man— a British art dealer with galleries in London and Hong Kong—described how, since the National Security Law, Hong Kong has returned to a "semblance of normalcy again."[22] Amazon Prime Video has two series, *Expats* and *Exciting Times*, both based on optioned novels about expats in Hong Kong, simultaneously in development and production. *Expats*, directed by Lulu Wang and co-produced by Nicole Kidman, was described as tone-deaf and as soft propaganda by the press, especially when Kidman received special treatment—having her COVID-19 quarantine waived—from the local

government.[23] Defending the decision, a statement was issued stating that Kidman's exemption was "conducive to maintaining the necessary operation and development of Hong Kong's economy."[24] These productions of the licit and sanctioned offer a fantasy intent on harmonizing, revitalizing, and stabilizing the image of Hong Kong. The immigration department granted visas for the foreign film crew, while at the same time, in the past year, denying visas for foreign correspondents and even scholars; foreign correspondents currently in the city worry that their visas may not be renewed. Promoted by financial stakeholders ranging from the state to global capital, the furnishing of this vision of ordinary life in Hong Kong—defined by forgetting, redacting, and obscuring—is relentless.

Lauren Berlant reminds us that crisis unfolds as a subtle perversion of ordinary life:

> Yet since catastrophe means change, crisis rhetoric belies the constitutive point that slow death—or the structurally induced attrition of persons keyed to their membership in certain populations—is neither a state of exception nor the opposite, mere banality, but a domain where an upsetting scene of living is revealed to be interwoven with ordinary life after all, like ants discovered scurrying under a thoughtlessly lifted rock.[25]

While a culture scrambles for survival against various threats, the licit and sanctioned image of Hong Kong as an enduring tax haven and a regional center of global capital reigns. On Twitter, a thread written by a man who describes himself as a Chinese lawyer "here to expose Western hypocrisy" went viral, showing people walking around a luxury mall. "My weekly walk thru IFC in Central to the gym to showcase the worsening 'oppression and unrest,'" the caption read, mockingly.[26] Parallel narratives of Hong Kong caught between rapid attrition and flourishing compete in defining the city. In the production of this new political reality, national and global capital are made accomplices. In private, we are left with a handful of feelings, constantly second-guessing, risking, and interpreting the material and spectral shapes that distinguish between danger and safety shifting around us. A sinister calm cordons the streets. As I write this, still more will change, and in one week, I will have left Hong Kong.

Notes

1. Agence France-Press, "'Intrusive Power': Concern over Proposed Hong Kong Law That Could Bar Anyone from Leaving City," *Hong Kong Free Press*, February 13, 2021, updated April 22, 2021, hongkongfp.com/2021/02/13/intrusive-power-concern-over-proposed-hong-kong-law-that-could-bar-anyone-from-leaving-city.

2. Office for Film, Newspaper and Article Administration, "Film Censorship Guidelines for Censors," June 11, 2021, ofnaa.gov.hk/filemanager/ofnaa/en/content_1398/filmcensorship.pdf. This link now goes to a new version of the guidelines, released on November 5, 2021, and still current as of October 2023. The language in this version reads: "The fact that a film may be perceived as a documentary of, or appear to be based on or re-enacting real events with immediate connection to the circumstances in Hong Kong necessitates an even more careful consideration of its contents by the censor, as local viewers may likely feel more strongly about the contents of the film or be led into believing and accepting the whole contents of the film, and the effect on viewers would be more impactful. The censor should carefully examine whether the film contains any biased, unverified, false or misleading narratives or presentation of commentaries, and the tendency of such contents to lead viewers to commit or imitate any act or activity endangering national security." A screenshot of the relevant excerpt from the original version appears in the following tweet: Antony Dapiran (@antd), "Apparent from the full guidelines that they rely on provisions of the law proscribing depictions of violence & crime (which inc NSL crimes). Interesting that [protest] documentaries are singled out for special attention. Full new guidelines here: ofnaa.gov.hk/filemanager/ofnaa/en/content_1398/filmcensorship.pdf," Twitter, June 11, 2021, twitter.com/antd/status/1403257711477699589?s=20.

3. Lok (@sumlokkei), "#hk – local film fest says showing of a short film 'has to be cancelled' becos [*sic*] the Office for Film, Newspaper and Article Administration 'failed to issue' either a certificate of approval or refusal to approve before the scheduled showing," Twitter, June 11, 2021, 3:47 a.m., twitter.com/sumlokkei/status/1403287794554793988?s=20.

4. Elson Tong (@elson_tong), "Hong Kong Office for Film Newspaper and Article Administration (OFNAA) demanded two documentaries on 2019 7.1 LegCo protest and Nov PolyU siege to add disclaimers. OFNAA then demanded the documentaries to keep it secret that OFNAA demanded the disclaimers," Twitter, September 21, 2020, twitter.com/elson_tong/status/14030801732 8236363777?s=20 (post removed).

5. Hong Kong Liberty 攬炒團隊 (@HKLiberty_Team), "#SiegeOfPolyU Documentary #InsideTheRedBrickWall won @idfa #InternationalDocumentaryFilmFestivalAmsterdam for Best Editing. #idfa #idfa2020 Its DVD was returned broken in pieces after producers sent it to #HongKong Office for Film, Newspaper and Article Administration for review," Twitter, November 27, 2020, 4:54 a.m., twitter.com/HKLiberty_Team/status/1332291802368520193?s=20.

6. Jerome Taylor (@JeromeTaylor), "The latest target for Ta Kung Pao is the Hong Kong Arts Development Council which it accuses in today's front page of 'funding black violence movies.' (TKP is part of the opaquely-owned media group that answers to Beijing's Liaison Office)," Twitter, March 16, 2021, 7:09 p.m., twitter.com/JeromeTaylor/status/1371991962304212995?s=20.

7. Taylor.

8. The case concerned a motorcycle driver who flew a flag emblazoned with the words "Free Hong Kong, Revolution of Our Times" in English and Chinese.

9. Patrick Frater and Rebecca Davis, "Shanghai Film Festival Abruptly Pulls Opening Film 'The Eight Hundred,'" *Variety*, June 14, 2019, variety.com/2019/film/news/shanghai-film-festival-pulls-opening-film-the-eight-hundred-huayi-bros-1203243335.

10. Ophelia Lai, "Hong Kong Art Space Raided Twice by Authorities," *ArtAsiaPacific*, June 15, 2021, artasiapacific.com/news/hong-kong-art-space-raided-twice-by-authorities.

11. Clifford Lo, "Hong Kong's National Security Law Hotline Draws 100,000 Tips in Just Six Months, Police Say," *South China Morning Post*, May 10, 2021, scmp.com/news/hong-kong/law-and-crime/article/3132880/hong-kongs-national-security-law-hotline-draws-100000.

12. "We Won't Let Arts Undermine Security: Carrie Lam," RTHK, March 17, 2021, news.rthk.hk/rthk/en/component/k2/1581040-20210317.html (article removed).

13. Quoted in Antony Dapiran, "No Place for Tiananmen Vigil in China's New Hong Kong," *Coda Story*, June 2, 2020, codastory.com/disinformation/beijing-hong-kong-protests.

14. Nan M. Sussman, *Return Migration and Identity: A Global Phenomenon, A Hong Kong Case* (Hong Kong: Hong Kong University Press, 2011), 6, 34.

15. Amber Wang, "'We'll Meet Again': Why a [*sic*] Hong Kong Artist Kacey Wong Chose 'Self-Exile' in Taiwan," *Hong Kong Free Press*, August 14, 2021, hongkongfp.com/2021/08/14/why-a-hong-kong-artist-kacey-wong-chose-self-exile-in-taiwan.

16. Stanley Prison jails male prisoners; Lai Chi Kok, males on remand; and Lo Wu, women. Siu Lam is the psychiatric facility that holds additional prisoners.

17. Jeffie Lam, "Welfare Petition with 100,000 Signatures Pours Heat on Hong Kong Prison Bosses to Protect Inmates from Sweltering Weather," *South China Morning Post*, May 23, 2021, scmp.com/news/hong-kong/politics/article/3134547/welfare-petition-100000-signatures-pours-heat-hong-kong.

18. Grace Tsoi, "Coffin Homes, Subdivided Flats and Partitioned Rooms in Hong Kong," *South China Morning Post, HK Magazine*, February 28, 2013, scmp.com/magazines/hk-magazine/article/2035259/coffin-homes-subdivided-flats-and-partitioned-rooms-hong-kong.

19. Jun Pang, "Domestic Workers Need Rules to Govern Air-Con Use, Claims Politician as Employer Faces Backlash over 'Inhumane Treatment,'" *Hong Kong Free Press*, August 10, 2017, updated March 31, 2020, hongkongfp.com/2017/08/10/domestic-workers-need-rules-govern-air-con-use-claims-politician-employer-faces-backlash-inhumane-treatment.

20. Quoted in "Three Hong Kong Arts Development Council Members Resign," *Artforum*, August 11, 2021, artforum.com/news/three-hong-kong-arts-development-council-members-resign-86332.

21. M+ museum opened in fall 2021.

22. Laura Westbrook, "'This Is My Home': Hong Kong's Foreign Residents Say They Have No Plans to Leave Because of National Security Law," *South China Morning Post*, July 31, 2021, scmp.com/news/hong-kong/society/article/3143207/my-home-hong-kongs-foreign-residents-say-they-have-no-plans.

23. Patrick Frater and Rebecca Davis, "Nicole Kidman and Amazon Series 'The Expats' Get Quarantine Exemption from Image-Conscious Hong Kong Regime," *Variety*, August 19, 2021, variety.com/2021/global/asia/nicole-kidman-amazon-the-expats-special-treatment-hong-kong-1235044441.

24. "Nicole Kidman Keeping Away from HK People, Says Govt." RTHK, August 19, 2021, news.rthk.hk/rthk/en/component/k2/1606655-20210819.htm (article removed).

25. Lauren Berlant, *Cruel Optimism* (Durham, NC: Duke University Press, 2011), 101–2.

26. Taro (@taro_taylor), "My weekly walk thru IFC in Central to the gym to showcase the worsening 'oppression and unrest' in 'communist' #HongKong Stay tuned for more horror next week! Love and kisses to all China watchers," Twitter, July 24, 2021, 3:12 a.m., twitter.com/taro_taylor/status/1418861679337684995?s=21.

Phantasms of Dissent

Hong Kong's New
Documentary Vernacular

Blurred faces and a largely undifferentiated mass of people make up the protagonists of the films *Taking Back the Legislature* (Hong Kong Documentary Filmmakers, 2020) and *Inside the Red Brick Wall* (Hong Kong Documentary Filmmakers, 2020). Depicting two critical events in Hong Kong's protests of 2019, the documentaries were shot in a time of relentless mass demonstrations, released in a stifling climate of crackdowns on civil society, and seen amid newly instated film censorship laws promulgated under a broad rubric of national security legislation. Produced collectively and credited anonymously out of concern for the filmmakers' safety, *Taking Back the Legislature* and *Inside the Red Brick Wall* illuminate the messy scrum of direct actions—their tensions, desperation, and stakes—in unflinching detail.

Yet all their vivid, often unsettling, depictions of violent arrests of protesters stop short of incriminating their subjects or making them identifiable. "Everybody has become porous. The light and the message go right through us," Marshall McLuhan observed aloud in 1977 at an appearance on the Canadian public broadcasting show *The Education of Mike McManus*. Seated in tight focus, with the camera facing the host, McLuhan reflected further: "When you're on the telephone or on radio or on TV, you don't have a physical body—you're just an image on the air."[1]

This disposition of the body on camera—delicate and wavering in the air, as McLuhan describes

it while himself "on air" in one of his last appearances on television before he died in 1980, presents a vision of the subject in disintegration under the pressure of state omniscience. "When you don't have a physical body, you're a discarnate being," McLuhan warns. "You have a very different relation to the world around you. And this, I think, has been one of the big effects of the electric age. It has deprived people, really, of their private identity."[2]

Some forty-five years after McLuhan's words on the porousness of the subject on-screen, the age of surveillance has become more pervasive, and new media, in instantaneous and networked circulation, have come to accelerate this deprivation of a person's being on film. Image capture, in the age of surveillance, is a process of dispossession.

Taking Back the Legislature follows the pivotal siege of the Hong Kong Legislative Council on July 1, 2019, which marked a shift in the ethos of the protests from civil disobedience to a more confrontational approach. *Inside the Red Brick Wall*, in turn, chronicles the twelve-day occupation at Hong Kong Polytechnic University. A period of four months separates the events recorded in the two films, and the police seem to have behaved differently on camera in the two works. For those not participating in them directly, the protests were often witnessed through fleeting clips circulated on social media, masked figures racing through clouds of tear gas or laser pointers shooting across a cityscape above the

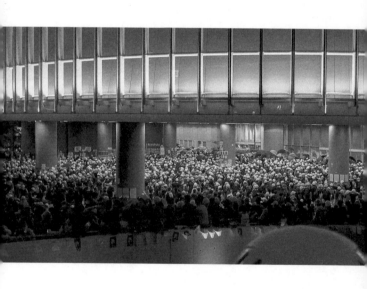

This page: Hong Kong Documentary
Filmmakers, still from *Taking Back
the Legislature*, 2020.

Previous page: Hong Kong
Documentary Filmmakers, still from
Inside the Red Brick Wall, 2020.

fires of barricades. Whereas the demonstrations beginning in June 2019 against an extradition bill proposed earlier that year had been characterized by tactics like the Bruce Lee–inspired "be water," with crowds fluidly assembling and dispersing to avoid being kettled, here the viewer encounters new strategies: the fierce and enduring occupation of a university or a siege of the halls of state power, exponentially raising personal and political stakes on the front lines.

These two recent works by the Hong Kong Documentary Filmmakers group illuminate the frontiers of documentary filmmaking and its ethics today, drawing a vivid narrative path between censorship and surveillance, even as they stand apart from prior conventions of advocacy documentary or news journalism. The filmmakers' choice to hold the frame tightly on a single event for each film differs markedly from other films about the protests, such as *Blue Island* (Chan Tze-woon, 2022), *Revolution of Our Times* (Kiwi Chow, 2021), and *Do Not Split* (Anders Hammer, 2020), which attempt to tell the story of the whole movement or assemble the connections between many parts of Hong Kong history. In the films by Hong Kong Documentary Filmmakers, the camera is constantly on the move, always trying to catch up to events as they unfold on the ground. The moving camera moves like a body and shakes and bumps and collides with other bodies.

In the ways that they challenge the canon of Hong Kong cinema, these works by the Hong Kong Documentary Filmmakers group must be read within a globally dispersed conversation about screen culture as related to surveillance cinema, but they must also be read materially within the juridical context in which they were made: during a time of crackdown on civil society and growing film censorship laws.

The films' protagonists constitute a phantasm of a spirit of dissent, challenging the convention of a singular identifiable protagonist. A style of filmmaking defined by the legal changes that deem any depictions of the 2019 protests seditious and in violation of the National Security Law of 2020, Hong Kong's emerging new cinema must be read formally within the context of that law, since these films become entangled with the passing of new film censorship regulations that bar them from being seen in Hong Kong while also complicating their release globally.

The Films Themselves

Taking Back the Legislature opens at 6:00 a.m. on the twenty-second anniversary of the handover of Hong Kong.[3] In contrast to the rest of the film, it is an eerily calm (and foreboding) beginning. Protesters pay respects with a series of repeated, ritualistic Taoist bows in front of a memorial for martyrs of the 2019

protest movement that has been pasted on a concrete wall. Nearby, black balloons, paper cranes, and flowers are ritually laid. A rain forecast forces the ceremony of the anniversary to move inside the Hong Kong Convention and Exhibition Centre, where Chief Executive Carrie Lam and other Hong Kong government officials are shown on-screen, intercut with televised footage of crowds singing the Chinese national anthem. A wide shot shows two helicopters flying overhead, one bearing a Chinese flag, while the other, flying lower and behind the first, bears the flag of Hong Kong. The weather begins to clear, and raised middle fingers emerge from the crowd of protesters, brandished at the helicopters.

What follows is a series of fierce negotiations on the protest's front lines, seemingly on the verge of boiling over and torpedoing the momentum generated by any previous actions. An anonymized mass of people clamors to orchestrate a series of critical decisions on the streets, winning collective consensus at every turn. As the day goes on, front-liners advance closer to the doors of the Legislative Council complex. Umbrellas move in formation toward the wall of police. Along the way, negotiations on the right time and strategy for storming the complex begin to erupt. After taking a vote, the crowd mobilizes to set a "defense line," assembling makeshift materials for barricades and personal protective gear, such as umbrellas, as shields against tear gas and pepper spray. They begin gathering water bottles

(to be used to douse and defuse tear gas canisters) as first-aiders, wearing helmets and yellow vests, and strapped with supplies including saline, begin to prepare for the upcoming conflict.

Over the course of this great odyssey, various figures emerge from the crowd, arguing with the front-liners and attempting to impede them from entering the Legislative Council. A young woman, pleading that there is no turning back, implores them to stop. The crowd retorts, asking her to tell that to the police. Later, an elderly woman tells the front-liners that the glass is unbreakable and that what they are trying to accomplish is a dead end. She is laughed off as the majority of protesters thank her and clap. Voices from the crowd, wary of potential agitators trying to diffuse the energy, remark on how there are "ghosts"—Cantonese slang for "spies"—among them.

When the front-liners finally near the glass doors, they meet face-to-face with pro-democratic Legislative Council members who argue that their actions must be led by reason—the last line in attempting to dissuade them from occupying the lawmaking body. The legislator Lam Cheuk-ting argues, "I just don't want you to get hurt and arrested." The protesters retort by asking him to open the doors for the front-liners in order to prevent this. One jeers sarcastically, "How much do you love your seat? Just say it. Say it today: 'I still want to be a legislator. I love my position.'" Lam Cheuk-ting

pleads, "All of us in the movement need to talk together." Another says flatly, "If you were capable of doing your job, we should have succeeded. We wouldn't even be here." As the protesters near the glass doors of the Legislative Council, still more attempts are made by other lawmakers. Claudia Mo asks, "Ten years' imprisonment for participation in a riot. Is it worth it?" A protester responds, "Worthwhile or not is not the question here. Your pandemocratic friends betrayed us all."

The filmmakers resist using any narration to streamline the film's timeline of events; these arguments, presented in their bare form, show the core of the grievances, their fierce entanglements, and the disagreements within the movement. By including varying perspectives, from those of journalists to those of state news outlets, the filmmakers were able to produce a singularly penetrating view into the heart of the front lines of protesters—their internal political debates with pro-democratic lawmakers, their debates with other protesters who favored civil disobedience, and even their encounters with the police.

Illustrating a story of entrapment, suspicion, fear, guilt, flight, and exhaustion, *Inside the Red Brick Wall* describes a slow process of attrition in a siege inside a university. Mirroring the first film, the event entailed protest strategies defying the "be water" ethos of the earlier Hong Kong protests, which had shifted locations and avoided kettling. In the occupation of Polytechnic University, protesters

—many of them appearing to be of high school or university age—attempted to cut off a city's main traffic artery and hold the economy hostage by laying siege to the university grounds, which are situated at the mouth of the Cross-Harbour Tunnel in Kowloon that leads to Hong Kong Island. But by using the tactic of a siege, the protesters became trapped within the walls of the university.

Again, instead of focusing on any one individual, the film features a mass protagonist, one with shared aspirations and internal contradictions. The viewer watches blurred faces, sometimes engaged in fierce disagreement, discuss how to deal with the menacing presence of the police. Unable to leave without facing arrest as police waited and surrounded the university, the protesters found themselves in the asphyxiating embrace of a police kettle that lasted over twelve days and resulted in 1,300 people being arrested, including first-aiders and human rights monitors.[4]

In one scene, a policeman on a loudspeaker launches into a monologue, reminiscent of the speech within a police academy taken from the script of *Infernal Affairs* (2002), soundtracked by music played to further taunt the protesters. The camera tightens in to focus on the police below, who cannot see the protesters barricading themselves. The protesters have blocked themselves from view in the high ground above, occupying a footbridge. The loudspeaker broadcasts the officer's voice to

them: "You are really rubbish. You talk without action. You cannot do a thing. You have no persever-ance. I despise you all. Not because you have no principles, no bottom line, no commitment or sense of responsibility. It's because you have no brain." Another cop echoes, "Well said."

Genre Roots, Reframed

Inside the Red Brick Wall and *Taking Back the Legis-lature* provide a fundamental challenge to the legacy of Hong Kong cinema, including the gangster-film and action-flick genres that feature criminals from the Hong Kong triad as much as they do the Hong Kong police. Hong Kong established its reputation as a global cinema capital through a prodigious output of kung fu pictures and "bullet ballets" that came to define genre filmmaking in Sinophone cine-ma and beyond. The city's cinematic contributions, especially from the 1980s to the early 2000s, consisted of crime thrillers, especially films about police, with titles such as *Police Story* (Jackie Chan, 1985), *Infernal Affairs* (Andrew Lau and Alan Mak, 2002), *Hard Boiled* (John Woo, 1992), and *PTU* (Johnnie To, 2003), all by directors who became recognized auteurs. This rich repertoire of films was influenced by Hollywood films of the time, but also proved to be inversely influential, inspiring titles such as Martin Scorsese's *The Departed* (2006).

A trope of these "copaganda" films—"shoot 'em up" flicks, gangster movies, and crime thrillers featuring police as central protagonists—is often a failure of justice or an unwanted or unjust outcome that requires the intervention of a cop. As the protagonist, he uses any means necessary, wielding excessive force or going against protocol to deliver justice. The irony of these productions is that many of them were funded by the Hong Kong underworld, which was rumored to have been laundering money through film production.

These films have historically promoted an image of Hong Kong police as "Asia's finest," a force that touts itself as one of the oldest, founded in British colonial Hong Kong.[5] These optics of the local police force have by now been grafted onto cinematic history. It is this legacy of the cop on film that is being challenged today across new media and in a surge of documentary films.

With cops now being documented in real time by both news outlets and citizen journalists via multichannel live streams of protests, residents across the city have been afforded new points of view, witnessing the front lines against police. The ubiquity of these live streams—distributing photos and videos of police using projectiles, tear gas, batons, and making violent arrests—has been politically galvanizing. Broadcast by both professional and citizen journalists, these emerging media forms became a new hearth by the light of which Hong Kong

people's perceptions shifted toward the unfavorable with regard to both police and the state. Images of incidents such as 8/31 (the 2019 Prince Edward Station attack, in which police shut down the train station and indiscriminately attacked people) were widely circulated online and became one of many pivotal moments in the Hong Kong protest timeline.

Less known globally is the nature of the Hong Kong film and entertainment industry, which had—and continues to have—strong ties to triads, or local crime syndicates. It is these same crime syndicates that were accomplices with Hong Kong police in such events as the Yuen Long attack, in which police and triad members were documented shaking hands at the entrance of a subway station that became the site of a mob attack on civilians who were alighting from the train.[6] The legacy of Hong Kong's canonical crime thrillers and films about police has been complicated by these actions taken by police operating in plain sight and with impunity, now embodying the rule of law as enforcers, regulators, and arbiters of corporal punishment.

As film historian Cameron L. White argues, the "traditional cinema—commercial, independent, or otherwise—played a minor role in the 2019 protests. Digital media was far more instrumental in connecting and mobilizing younger generations, while also offering a vibrant playground for Hong Kongers disenchanted with longer-standing modes of image production."[7] Real-time videos of police

circulated through social media, serving as critical material to energize protests. Cops were seen embodying the "state of exception"—that is, a sovereign ability to transcend the rule of law or dictate it via police conduct carried out in the name of maintaining public order. These images were highly politicizing, attesting to the decisive transformation of Hong Kong screen culture from one with a legacy of fictional films to one with a legacy of political documentary.

In a Time of Revolt, a Revolt against Time

Resisting conventions of advocacy documentary and journalism that reduce any collective voice to individual ones, the Hong Kong Documentary Filmmakers group has created a new view of protest and social change. A surfeit of fierce divisions and negotiations within the movement overflows onto the streets. This style of documentary filmmaking—carefully assembling messy, dispersed materials from multiple filmmakers so that they form one narrative—engages the viewer in the liveliness of these events, unfiltered, in advance of any narrativization to be produced by historians, news anchors, or even elite activists.

"The standard account promoted by revolutionary elites," political scientist James C. Scott argues, "is buttressed by the way in which the histor-

ical process itself 'naturalizes the world,' erasing evidence of its contingency. . . . In the same way, none of the historical participants in, say, World War I or the Battle of the Bulge, not to mention the Reformation or the Renaissance, knew at the time that they were participating in anything that could be so summarily described."[8] In the aftermath of 2019, the protests have often been described in shorthand as a pro-democracy movement. While the aim of the protests was indeed to attain universal suffrage, the difference between struggles in the street and confrontations with police as depicted in *Taking Back the Legislature* and *Inside the Red Brick Wall* tells a nuanced tale of political strategies and their efficacy. Such significant disagreements captured on the front line illuminate a critical oral history—what Scott calls the "evidence" of a historical event's "contingency."[9] With the filmmakers themselves uncertain even of the outcome of the day, every minute captured seems to portend a key turning point, an unknowable outcome just around the bend.

These works capture a highly elusive sense of time in the midst of revolt. It is, as political theorist Achille Mbembe writes, "necessary to think about the status of that peculiar time that is *emerging time*." Mbembe continues:

> To think relevantly about *this time that is appearing*, this *passing time*, meant abandoning

conventional views, for these only perceive time as a current that carries individuals and societies from a background to a foreground, with the future emerging necessarily from the past and following the past, itself irreversible. But of central interest was that peculiar time that might be called the *time of existence and experience*, the *time of entanglement*.[10]

Devoid of any soundtrack to prompt tone, and with no consistent narration to summarize or contextualize events, both *Taking Back the Legislature* and *Inside the Red Brick Wall* immerse the viewer in the burning fury of rage, doubt, and fear that the protests evoked. These events, edited in relentless succession one after another, grant no respite to the viewer, offer no easy resolution, no hope in the outcome. This emotional palette of a pivotal moment of revolt in Hong Kong tells of a time of painful and prolonged entanglement with state violence.

In a key scene in *Taking Back the Legislature*, the protest proceeds in full awareness of the stakes involved, both politically for Hong Kong and personally for participants, in terms of possible imprisonment for rioting. The protesters face the task ahead of them: to occupy the halls of state and legislative power. As their conversation begins to trail off and stagnate, the crowd of protesters yields to clear space for an empty circle, bodies moving as if

searching for a mosh pit, and a makeshift barricade emerges. Joined together by zip ties, an arrow-head-shaped barricade is assembled from metal street barriers. Umbrellas hang along the side, meant to be easily accessible for protesters in the inevitable event of police pepper spray. Cameras are ubiquitous: there is a pit of journalists who at first outnumber the front-liners leading the charge. A repurposed metal garbage collector weighted down with a pile of flattened cardboard emerges. Umbrellas open around the front-liners, who move into a defensive line.

Lawmakers outside the doors make final attempts to stop them, pleading with the protesters, "You cannot save Hong Kong this way. You'll drag others in. You will only hurt more people." In the distance, chants from the crowd drown them out: "Add oil, Hong Kongers!" The action now is inevitable. The first crash inspires the cops, sheepish-looking, to run up to the glass with their own video cameras. Some are gesturing toward the protesters, yelling but inaudible outside. One looks uncertain, pulls up to the window, slowly clutching a shield, eyes darting. The lawmakers attempt to reason with the police through the glass. A woman whose face is blurred writes a message to the police and holds it against the pane, a drawn heart, asking them not to rush the protesters—a hand-drawn plea for mercy. A group begins to wield metal poles in an attempt to break the glass, making thuds against the shatterproof

facade. The shatterproof glass is stubborn and eventually forms spiderweb-like fractures along its surface, which the police—blank-faced, some looking more uneasy than others—peer through.

Unlike the fictional films of Hong Kong's past that featured chase scenes between cops and criminals crashing through glass, the shatterproof glass that protects the halls of the Legislative Council from intrusion does not shatter easily. An intertitle appears: it takes the protesters four hours to break through. When the glass finally gives way, it dislodges from the frame of the doorway in one intact piece, and protesters push over the threshold.

Building upon the legacy of imported action films of previous decades, a film such as *Taking Back the Legislature* marks a new era of documentary filmmaking—one that, from the middle of an uprising, reshapes the legacy of on-screen "crime thrillers" in Hong Kong. Depicting each tactical action as if part of an instructional manual to circulate globally for protesters in other cities, it also draws connections for a new global movement wherein "action" takes insurgent form.

From Movement to Siege

A siege is literally defined as a "military blockade of a city or fortified place to compel it to surrender."[11] *Taking Back the Legislature* and *Inside the Red Brick*

Wall are both films that record the symbolic usurpation of institutional architecture—from the halls of state power (the heart of lawmaking in a semiautonomous one-country, two-systems political framework) to the university campus that fed talent to the major industries of Hong Kong: business, construction, engineering, hotel and tourism management, and others.

This glass that the protesters break in the climax to *Taking Back the Legislature* is the membrane through which the protests pass to a point of no return, leading to a tonal shift that both foreshadows and informs the next film, *Inside the Red Brick Wall*. The events of the Hong Kong protest timeline trace the exact moment of this radical shift between passive tactics of civil disobedience and demonstration on the one hand, and a more confrontational approach to penetrating and occupying the halls of state power on the other. Once inside the Legislative Council, the protesters attempt to occupy the space for as long as possible.[12]

In one scene shot inside, black spray paint is used to cover the Hong Kong bauhinia emblem, as if redacting the symbol above the center of the Legislative Council floor. One blurred face speaks: "We urge more Hong Kongers to come forward. To reclaim our council. Hong Kongers need to reclaim the council." After more speeches, one protester removes his face mask to address a pit of journalists: "If you have the ability to, occupy this

place! If you don't, you could besiege the Legislative Council and peacefully use your bodies to protect us. We cannot afford to lose any more." Aware that the journalists around him are broadcasting live, and speaking into the multiple cameras to command bodies to join in resistance, he continues, "We care about our homeland. We risk our bodies to guard our homeland." The biopower of resistance is displayed in the film, from the arc of the narrative of bodies negotiating to enter the halls of state power to the gestures made inside. The protesters outside on the streets, he beckons, should hold the legislative halls from the outside in a protective embrace.

Months later, although not captured in this film, pro-democratic lawmakers would be physically dragged out of the same halls. Described lightly at the time by foreign newspapers as a "brawl" between pro-Beijing and opposition lawmakers,[13] the elimination of all pro-democratic or oppositional lawmakers from the legislative floor on May 18, 2020, would foreshadow the National Security Law of June 30, 2020, followed by the mass arrest of fifty-three elected pro-democracy officials and activists on January 5, 2021.[14]

By late 2021, all pro-democratic lawmakers had been jailed and charged with violating the National Security Law of 2020, with a potential life sentence in prison. Many still await sentencing in prison. Some had already fled and self-exiled from Hong Kong. *Taking Back the Legislature* ends with a

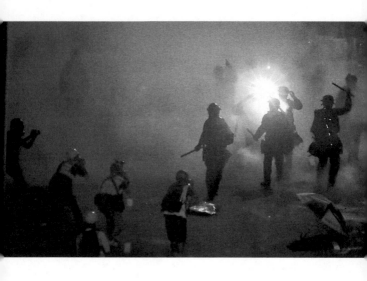

This page and previous page:
Hong Kong Documentary
Filmmakers, stills from *Taking
Back the Legislature*, 2020.

police crackdown on the protests along the harbor front as protesters leave the Legislative Council space. The perspective of the camera veers from a cloud of tear gas to wide shots of police clearing the street, indicative of the dispersed angles around the event by filmmakers operating as a collective. At the end, a single camera runs up into the empty halls of the Legislative Council, breathless, as if to catch a glimpse of it one last time. Moving from a direct cinema style to a subtle imprint of vérité, the camera operator can be heard breathing as the camera affords a view of a defamed legislative hall.

Taking Back the Legislature depicts insurgent actions that lie outside the bounds of propriety, taken by social actors whose actions in these spaces of state power are a challenge to sovereignty, and who are participating in a history of storming the architecture of state power as a critical event of revolution, a challenge to the very legitimacy of power. As Hong Kong cultural theorist Ackbar Abbas observed, prior to the handover of 1997:

> As a city, Hong Kong has been very much the plaything and ambiguous beneficiary of history. Colonized by the British in the nineteenth century; occupied by the Japanese in the Second World War; swelled by the influx of refugees from communist China after 1949, which gave it so many of its cooks and tailors and entrepreneurs; taken in hand by

the multinationals as it developed into an international city; and now to be returned to China: Hong Kong's history is one of shock and radical changes.[15]

The protesters' ritualistic gestures enter a political history of protest as animating grievance through the bodily occupation of symbols of state power, making connections to various occupations and acts of civil disobedience that have usurped space for resistant ends; the single protester who unmasked himself inside the legislative chamber even makes reference in his speech to the Sunflower Student Movement in Taiwan in 2014. *Taking Back the Legislature* captures what Abbas considers how "history exists, if not in monuments or written records, then in the jostling anachronisms and spatial juxtapositions that are seen on every street; that is, history is inscribed in spatial relations."[16] Here, in the work of Hong Kong Documentary Filmmakers, history is on display in spaces of symbolic political power, grafted onto the moving image and put into circulation amid networked relations of global multivectored insurrection.

Beyond Opacity: Documentation as Capture

The exposure of an individual's face is a critical element, offered in contrast to the mass of faces that have been blurred or obscured. The unmasked protest-

er in the Legislative Council is aware he is exposing himself to show the extent of the stakes of the movement; in fact, as a result of exposing himself in this siege, he would later self-exile.[17] Being captured on film adds an additional layer to the relationship between contingency and the moving image. As Mary Ann Doane describes about an earlier time and artifact:

> What was registered on film was life itself in all its multiplicity, diversity, and contingency.
> This archival desire is intimately linked to the technological assurance of indexicality. The fidelity of the image to its referent was no longer dependent upon the skill or honesty of a particular artist. The imprint of the real was automatically guaranteed by the known capability of the machine. For the first time, an aesthetic representation—previously chained to the idea of human control—could be made by accident. This strengthened the medium's alliance with contingency.[18]

This quality of contingency is also present in the ways images live on, and even in how one might anticipate that images will live on. The archival impulse also spells out the cost of being recorded. To be captured on film committing such insurgent actions is to experience an act of violence; yet at the same time, participants rely on the media and cameras to record

these bodies and the historical significance of their actions in the halls of state power to make these acts count. They even consciously use live broadcasts around them to try to galvanize their comrades into action. Taking occupation of such a space registers public meaning as a symbolic act when such an act is widely visible. Those participating are consciously being registered as demonstrating discontent and are aware that their images will interrupt the news cycle.

Exposed on this stage, with dozens of cameras capturing their actions and likenesses, protesters behave on camera with an acute and strategic awareness of their relation to cameras. Negotiating around the dozens of cameras surrounding them, masked protesters behave as an anonymized mass, aware of the weight of their actions as a symbolic takeover of political space. Still, they know that they are incriminating themselves for these same actions that are politically powerful and symbolic; they know that they are being caught on camera committing acts that can land them in jail for up to ten years, or worse; that can, through a system of increasingly opaque courts, cause them to be disappeared by the state. Thus "capture" is revelation as well as material evidence. The relationship between cinema and surveillance becomes especially vivid—or, as film historian Catherine Zimmer states, when "practices of surveillance become representational and representational practices become surveillant . . . ultimately the distinctions between the two begin to fade

away."[19] The status shifts, and the moving-image apparatus, to borrow the title of a book by James C. Scott, sees like a state.[20]

Filmmaking today, especially that which is made at the front lines of revolt against state power, elaborates on the contingency of cinema such that the afterlives of images, circulated broadly or leaked, make their capture potentially incriminating. The images they convey serve as evidence, as snares, as open wounds and spilled secrets.

Highly mediated captures of insurgent action are iterative, building upon a recent ten-year span of global uprisings in which "real time" and the moving image have gained new, violent meaning. Writing on the Arab Spring, Donatella Della Ratta elaborates:

> With the Arab uprisings, particularly with Syria, the enmeshment between violence and visibility reached its peak: the 2011 street movements carry an unprecedented net-worked dimension that inscribes both the act of a peaceful protestor filming with a smart-phone and that of an armed man raising his gun to shoot at them—both the cam shot and the gun shot—into a dynamic of participatory culture. Immediately, the violence performed on the ground is rendered into a digital commodity available to be copied, shared, manipulated, and liked—all within the

economy of the social web. This aspect never emerged before, even in highly mediatized yet pre-networked conflicts, like Iraq in 2003.[21]

Residing not only in "real time" but also through the mediated timelines of Twitter and the web's twenty-four-hour news cycle, ruled by the rapid circulation of media, such documentation offers material evidence, or visible proof, of criminality. Yet the work of the Hong Kong Documentary Filmmakers group, themselves anonymous to ensure their own security, attests to a different model of filmmaking that transcends surveillance cinema in practice and proposes a filmmaking that itself joins the subjects portrayed in anonymity and fugitivity. Theirs is a filmmaking that specializes in unlearning "the optics of the State that we have internalized," as Peter Snowdon writes of such fugitive approaches to filmmaking, which join the subject in telling the story of the self through its subject. As Snowdon argues:

But to film as the person who made this video does—with a willingness to sacrifice optical clarity for the sake of fidelity not to one body (her own), but to the plural body of the collective and its multiple and potentially contradictory affects—is to accept that part of opacity that is always present, both within us and without us, and which cannot be elim-

inated. For it is that opacity of both the individual and the collective body which makes another kind of politics possible.[22]

When the protesters realize the police are not coming to arrest them once inside, they fear they have been ensnared in a trap and begin negotiating a time to leave. As the arguments intensify, an incredible gesture in the film begins to emerge. The protesters' shoes are blurred, and then most of the screen, for a few moments, is redacted: obscured bodies and faces cover the frame. Escalating into heated disagreement over when to leave the Legislative Council, and realizing that they must all do it together, protesters begin dragging one another out of the lawmaking chamber, pushing onward so the movement can keep going after this day. They scream that they must all leave together and not leave any person behind. The composition of the frame for a few moments appears almost impressionistic, as the hazy figures tussle and erupt in disagreement. These figures—opaque, obstinate, and abstracted by blur— avoid the camera's capture for several moments as the entire frame is occupied by blurred bodies and faces.

The expansion of national security issues in Hong Kong extends the criminalization of a broad range of acts under four categories: subversion, succession, terrorism, and collusion with foreign forces. Moreover, the National Security Law passed in 2020 may be applied retroactively, and even to

offenses committed outside the jurisdiction of Hong Kong or any Chinese territory. Singling out the genre of documentary, Hong Kong film censorship guidelines state: "The fact that a film purports to be a documentary or purports to report on or re-enact real events with immediate connection to circumstances in Hong Kong necessitates an even more careful consideration of its contents by the censor."[23] The language of the National Security Law suggests that any materials that depict or mention the protests could potentially be deemed a threat to sovereignty and therefore be vulnerable to deletion, erasure, and censure.

"Blurring of the image, that is, to bewilderment rather than to understanding," as Ackbar Abbas has stated, means that "the closer you look, the less there is to see."[24] In many frames of this film, it is "as if every shot has to be closely attended to, because things are always surreptitiously passing you by. This is the *déjà disparu*, a reality that is always outpacing our awareness of it, a reality that the film continually tries to catch up with."[25] Abbas was actually writing about Wong Kar-wai's debut film, *As Tears Go By* (1988), but his description of its techniques of blurred image, rapid camera movement, and Hong Kong's unstable historical and temporal space resonates eerily here.

Rather than push an audience into dissociating and disconnecting from this mass of protagonists, the anonymized images in *Inside the Red Brick*

Wall and *Taking Back the Legislature* have the effect of allowing these figures to take on a spectral presence, their bodies and spirit constituting the dimensions of a protagonist. The viewer hears the roar of their differences and the emboldened spirit of their solidarity. They appear phantasmagoric as their distorted faces make a menacing point about the vulnerability of the subjects. The viewer cannot see them, because it is unsafe to do so.

On the power of redaction, Travis Linnemann and Corina Medley state, "As a recognition of and resignation to the (un)known, these redacted black spaces therefore reveal a distinct mode of political subjectivity. It is here, amidst the everyday terror of police and prisons, that some political subjects admit, 'I see that there is nothing to see.'" What the viewer sees has not been erased, "but occluded by a purposefully created void."[26] Protesters can be distinguished only by their limbs, the variations between their masks and helmet styles, and small differences in the black clothes they wear. Without context for these individuals—their jobs, schools, neighborhoods, or even ages—the mass as protagonist is an undifferentiated collective. The audience can only guess at their ages based on the framing of their bodies, their voices, possibly even their gestures. The unknown political consequences of their actions, such as years-long or even life sentences for participation in demonstrations, and even the fear of disappearance, only intensify in *Taking Back*

the Legislature, made at a time when the protests were escalating unceasingly. The stakes become higher and actions more desperate.

In *Inside the Red Brick Wall*, there are fewer and fewer journalists are seen on campus documenting the siege as the days go on—a troubling sign, since their phone and television screens represent the only tether to the world outside the university walls. These feeds offer protesters glimpses into protests around the city, including attempted rescues where other groups of protesters try to get as close to the university as possible to save them. Yet it is also through these digital feeds that protesters' worst fears are stoked while they are trapped: a video, circulating online, is seen playing on a phone in a protester's hands, depicting a police officer who is overheard threatening a repeat of Tiananmen Square at Polytechnic University. In the only interview in either film where a subject speaks to the camera, a man whose face is blurred and covered in a ski mask says, "Seems we are completely surrounded. And there aren't a lot of journalists here. In here, if I die, no one will know. Although I'm prepared to die, I don't want to die with no one knowing. If I get arrested outside or thrown off a building, at least my body can be found. By being arrested when no journalists are present, I could disappear without a corpse. I actually am very scared at heart."

As Avery Gordon states, "The disappeared have lost all social and political identity: no bureau-

cratic records, no funerals, no memorials, no bodies, nobody."[27] It is their ghostly presence that haunts the screen in *Inside the Red Brick Wall*—resulting in a shift in tone that owes to feelings of desperation and the rapid attrition of a prolonged siege. As much as cinema can be mobilized as "proof" and "evidence," it also serves here to illuminate an event in the Hong Kong protests, one in which many from the outside didn't have visibility into the extent or nature of events happening inside the university walls in which the protesters were trapped, and the number of journalists dwindled even as the occupation endured. Rescues were attempted, including some involving motorbikes taking away protesters who rappelled from a highway overpass down a few stories to another road. The protester who gave the short interview carried a bow and arrow, and his face was masked and his eyes blurred out. The act of being recorded becomes a way for him, albeit anonymized, not to disappear totally without a trace.

Although the fates of the lawmakers and elite movement activists are known, those of the faceless collective that made up the Hong Kong protests, or of the front-liners in both films, remain unknown. There have been glimpses of sentencings in the news, but as the courts processed the large volume of arrests from the protests, the fervor of news media and the appetite for spectacle have dissipated, accelerated by the political pressure on journalists.

There is a single uninterrupted five-minute take in the middle of *Taking Back the Legislature* that depicts protesters attempting to scramble through an escape route on a highway overpass, none of their faces obscured. Intercepted by cops, they are picked out of a stream as if the police were hunting. Between the shelling of tear gas rounds and other projectiles, groups of police capture protesters and pin them to the ground. The camera swings to film one person who has been pinned to the ground, with one shoe on and the other foot bare. Another person is being yanked around by the police while trying to wring free. You can hear journalists around him, capturing the arrest, ask for his ID and name—a way to try to keep people from being disappeared by the state. The restless camera drifting from face to face shows all these people's faces without blurring. The film deliberately implicates the viewer as witness to their existence. Subtle gestures speak to a sensitivity around faces and how the camera engages with whether people want to be seen or not seen. Another woman, aware of the camera in front of her, attempts to say her ID number and name, while several cops converge on top of her, including one who kneels on her back. The camera gets closer as her gas mask is ripped off. She manages to say her whole Chinese name and ID number, even as a cop shoves her face into the ground.

From historical revision and denialism to criminal liability and potential infringement on

national security, censorship in the name of national security initiates an epistemic crisis. It is imperative to read these films in the political and legal context within which they have been made, but equally to study them through a lens focused on the obstacles inherent in the censorship, screening, and circulation restrictions in place in Hong Kong and beyond.

Such a study can illuminate the ways in which the formal gestures seen throughout the works of the Hong Kong Documentary Filmmakers function to identify the void that is present in what the viewer can see. In depicting acts of resistance, a film grammar is emerging that favors obtuse expressions—the blurring of an image, the status of front-line negotiations as critical oral histories, and the choreographing of disparate materials into a collective work. Through the Hong Kong Documentary Filmmakers' elegant organization of chaotic material, one is better able to see, in all its fullness and complexity, the action on the ground.

The communal and diffuse gaze of collective filmmaking mounts a powerful alternative to the long-held authority of the voice of a single author. Gestures of blurred faces are selective throughout the film—not to be read as a sign that the filmmakers simply failed to obtain release forms, but rather as proof that they are actively protecting the individuals as subjects who they depict on film. Their excessive use of blurring, even of a protester's shoes, and the favoring of oblique and opaque perspectives by

which to show the actions on the front lines, are modes of critically resisting the danger of visual media as material that potentially acts as witness to violations of the law or as evidence that incriminates or makes subjects on-screen liable.

Such formal tactics may be read as animating Édouard Glissant's sense of the right to opacity, but should be located more specifically as gestures claiming a right to blur, a right to control leaks, and a right to stop the light from penetrating the subject. A blurred and collectively constructed protagonist defies narrative expectations for a singular exposed protagonist who petitions the viewer for empathy. Amid varying perspectives, from journalists to state news outlets, the filmmakers were able to accomplish a singularly penetrating view—from the heart of the front lines, between protesters and police—that resists documentary conventions of advocacy journalism while avoiding foreclosure by moralization.

Notes

1. Marshall McLuhan, "Marshall McLuhan in Conversation with Mike McManus," *The Education of Mike McManus*, season 1, episode 47, aired September 19, 1977, on TVOntario, tvo.org/video/archive/marshall-mcluhan-in-conversation-with-mike-mcmanus.

2. McLuhan, "Marshall McLuhan in Conversation with Mike McManus."

3. For those unfamiliar with Hong Kong history, July 1, 1997, marked the British ceding of Hong Kong to China after 156 years of colonial possession.

4. Jessie Pang and Martin Pollard, "Hong Kong Police Exit Wrecked Campus, Weekend Protests Planned," Reuters, November 28, 2019, reuters.com/article/uk-hongkong-protests-idUKKBN1Y302G.

5. Hong Kong Police Force, "Hong Kong: The Facts: The Police," August 2022, police.gov.hk/info/doc/hkfacts_en.pdf.

6. Kelly Ho, "Explainer: From 'Violent Attack' to 'Gang Fight': How the Official Account of the Yuen Long Mob Attack Changed," *Hong Kong Free Press*, July 21, 2021, hongkongfp.com/2021/07/21/from-violent-attack-to-gang-fight-how-the-official-account-of-the-yuen-long-mob-attack-changed-over-a-year.

7. Cameron L. White, "Pixels, Police, and Batons: Hong Kong Cinema, Digital Media, the 2019 Protests, and Beyond," *Film Quarterly* 74, no. 3 (Spring 2021): 10.

8. James C. Scott, *Seeing Like a State: How Certain Schemes to Improve the Human Condition Have Failed* (New Haven, CT: Yale University Press, 1998), 93.

9. Scott, 93.

10. Achille Mbembe, *On the Postcolony*, trans. A. M. Berrett, Janet Roitman, Murray Last, Achille Mbembe, and Steven Rendall (Berkeley: University of California Press, 2001), 16.

11. Merriam-Webster, s.v. "siege," accessed January 21, 2022, merriam-webster.com/dictionary/siege.

12. For American audiences today, the storming of the legislature may invoke (unwarranted) comparisons to the storming of the US Capitol that occurred in Washington, DC, on January 6, 2021, almost two years after this event. But there is a danger in making equivalences between Hong Kong and elsewhere. Even the word "leftard," uttered by a protester in one of the early arguments with a lawmaker, is a term translated from the Cantonese slang *zuo gau*. This usage suggests that it is referring to a group of people who impede the insurgent actions of the movement and also that it connotes those who are too naive, idealistic, and impotent to be useful in actions. The meaning of *zuo gau* has shifted since then through online usage to refer instead to the "far left." Here, then, is another cross-cultural challenge to the translation of these terms that gets to the heart of the confusion over whether the "left" and "right" values of Hong Kong's protest movement match American ones. Even in Cantonese, what is referred to as "right-wing" in fact refers to the ideology of the Chinese state. Another challenge to translation: the nomenclature of a political movement is idiosyncratic. In these films, geopolitical macronarratives and ideological debates are displaced by the essential stories from the front lines.

13. Tiffany May, "Hong Kong Legislators Brawl amid Fears over Widening Chinese Control," *New York Times*, May 18, 2020, nytimes.com/2020/05/18/world/asia/hong-kong-protests-fight-legco.html.

14. Zen Soo, "Hong Kong Arrests 53 Activists under National Security Law," *AP News*, January 6, 2021, apnews.com/article/legislature-primary-elections-democracy-hong-kong-elections-25a66f7dd38e6606c9f8cce84106d916.

15. Ackbar Abbas, "The New Hong Kong Cinema and the *Déjà Disparu*," *Discourse* 16, no. 3 (Spring 1994): 67.

16. Abbas, 67.

17. Eileen Guo, "Unmasked Hong Kong Protester Says from US: We Want 'Full Democracy Not Independence—But Some Violence Is Justified,'" *South China Morning Post*, September 20, 2019, scmp.com/news /china/politics/article/3029612/unmasked -hong-kong-protester-says-us-we-want-full -democracy-not.

18. Mary Ann Doane, *The Emergence of Cinematic Time: Modernity, Contingency, the Archive* (Cambridge, MA: Harvard University Press, 2002), 22.

19. Catherine Zimmer, *Surveillance Cinema* (New York: New York University Press, 2015), 2.

20. See Scott, *Seeing Like a State*.

21. Donatella Della Ratta, "Shooting 2011–21: Violence, Visibility, and Contemporary Digital Culture in Post-Uprising and Pandemic Times," *Film Quarterly* 75, no. 2 (Winter 2021): 70.

22. Peter Snowdon, *The People Are Not an Image: Vernacular Video after the Arab Spring* (London: Verso, 2020), 72.

23. The Government of the Hong Kong Special Administrative Region, "Amendments to Guidelines for Censors under Film Censorship Ordinance Gazetted," June 11, 2021, www.info.gov.hk /gia/general/202106/11/P2021061100239. htm. After their original publication in June 2021, a new version of the guidelines was released on November 5, 2021. This version, still current as of October 2023, uses slightly different language: "The fact that a film may be perceived as a documentary of, or appear to be based on or re-enacting real events with immediate connection to the circumstances in Hong Kong necessitates an even more careful consideration of its contents by the censor, as local viewers may likely feel more strongly about the contents of the film or be led into believing and accepting the whole contents of the film, and the effect on viewers would be more impactful. The censor should carefully examine whether the film contains any biased, unverified, false or misleading narratives or presentation of commentaries, and the tendency of such contents to lead viewers to commit or imitate any act or activity endangering national security." A screenshot of the relevant excerpt from the original version appears in the following tweet: Antony Dapiran (@ antd), "Apparent from the full guidelines that they rely on provisions of the law proscribing depictions of violence & crime (which inc NSL crimes). Interesting that [protest] documentaries are singled out for special attention. Full new guidelines here: ofnaa.gov.hk/filemanager/ofnaa/en /content_1398/filmcensorship.pdf," Twitter, June 11, 2021, twitter.com/antd /status/1403257717477699589?s=20.

24. Abbas, "New Hong Kong Cinema," 71.

25. Abbas, 71.

26. Travis Linnemann and Corina Medley, "Black Sites, 'Dark Sides': War Power, Police Power, and the Violence of the (Un)Known," *Crime, Media, Culture* 15, no. 2 (August 2019): 341–58.

27. Avery Gordon, *Ghostly Matters: Haunting and the Sociological Imagination* (Minneapolis: University of Minnesota Press, 2008), 80.

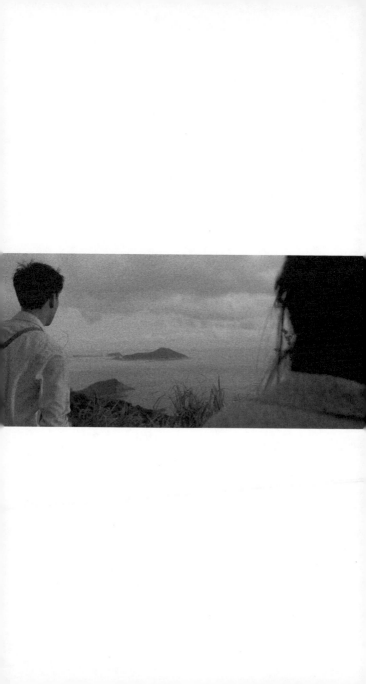

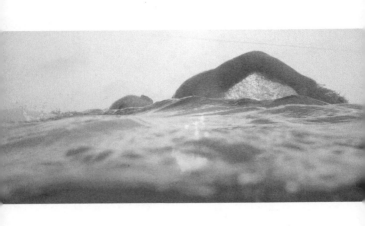

This page and previous page:
Chan Tze-woon, stills from
Blue Island, 2022.

Elliptical Returns

Reconfiguring Publics in Former and New Hong Kong Cinema

Hong Kong cinema is yoked to nostalgia. Sometimes called its golden age, the period of iconic films in the 1980s and 1990s is roughly flanked by two major historical dates: 1984, the year of the joint declaration between the British and Chinese governments that set the date for the handover of Hong Kong to China and outlined the idea of "one country, two systems"; and 1997, the year of the handover itself.

As Ackbar Abbas wrote in the midst of this period of cultural production, the era was the *déjà disparu* of the cinema of the time: "The Joint Declaration caused a certain amount of anxiety. . . . It made Hong Kong people look at their country with new eyes. It is as if the possibility of the disappearance of this social and cultural space led to seeing it in all its complexity and contradiction for the first time: an instance, as [Walter] Benjamin would have said, of love at last sight."[1] There was an anticipatory nostalgia baked into films of that time that self-consciously reflected upon the city's—and cinema's—ephemeral present. New Hong Kong cinema today, thirty years on, continues this self-reflexivity of Hong Kong present and past, making the city its subject.

Yet the cinema of this former golden era, as Abbas argues, is interesting "because of the way film is being used to explore and negotiate a problematic and paradoxical cultural space without abandoning its role as popular entertainment."[2] Hong Kong filmmakers today live out the subject of that political anxiety, which fueled the earlier cinematic boom,

even as they face intense legal risks in filmmaking, especially documentary filmmaking. By contrast, they are more explicitly political than their predecessors, taking history or political events as subjects, and are interested not just in fictional narratives but in bringing their focus on genre into hybrids of documentary and nonfiction filmmaking. This political anxiety, now articulated more urgently as fear and paranoia, endures today. The new era is defined not so much by a commitment to what is "popular" or "entertainment," as it was for their predecessors, but by circumstances and legal risks that prescribe a different sphere entirely: a new Hong Kong cinema that lives on as fugitive and exilic.

The "Hong Kong Free Cinema Manifesto," recently translated into English, feels like a confessional glimpse into the current scene and is signed by filmmakers working in the city today. First published in 2022, after the passing of the National Security Law of 2020, it has been signed by over thirty contemporary Hong Kong filmmakers—who, notably, are using their own names at a time when many works are being released anonymously (as in the case of Hong Kong Documentary Filmmakers), and when many filmmakers are self-exiling in fear of political persecution for making films (as in the case of documentary filmmaker Tammy Cheung). Citing films that have been banned locally, the manifesto states that "filmmakers face increasing difficulties in securing financing or risk being

blacklisted from the mainstream industry."[3] As the city's funding is withdrawn and producers pull out of projects that are explicitly political, production houses close up and resources are drying up from within.

Writing in the introduction to the volume *Film and Risk*, Mette Hjort issues a reminder that risk in filmmaking is not just political but financial:

> The continued existence of films that are both a form of cultural heritage and a vehicle for cultural memory comes to depend on the outcome of probabilistic reasoning in relation to clearly defined threats[,] . . . [and often the model of] government-subsidized filmmaking . . . redefined the economic risks (that is, losses) associated with national film production as the inevitable costs of sustaining national cultures.[4]

Yet in this new era, when Hong Kong cinema is in direct opposition to national or state interests, financial risk is dispersed and shouldered not by the state, or investors, but by the filmmakers themselves.

To define Hjort's phrase "film and risk," it is critical to understand not just political risk in terms of disappearance, rearrest, doxxing, attack, or forced exile, but also through extant dimensions of risk that encompass personal financial debt and bankruptcy in support of an independent film practice. Even

participating in a political project, as the manifesto suggests, might endanger one's ability to keep a day job within the industry. These types of financial attrition are the implicit terms for a Hong Kong cinema that is imploding as the city's public funding is disappearing, and as producers, afraid of being associated with political projects, are deserting filmmakers.

Self-conscious about legacy as much as history, the "Hong Kong Free Cinema Manifesto" gestures at the weight of nostalgia carried by the fabled golden era of commercial Hong Kong filmmaking. Citing such films as *Days of Being Wild* (Wong Kar-wai, 1990) and *A Chinese Odyssey* (Jeffrey Lau, 1995), the manifesto states: "Every single frame of our films [is] undergirded by this tradition of filmmaking that has evolved into different structures of feeling over the past century. It is through this understanding that we can break through and make a new generation of Hong Kong cinema."[5]

Nostalgia Overdrive

The resurgence of Hong Kong cinema of this golden age among international audiences seems to be cyclical. Art-house cinemas in major global cities —such as Film at Lincoln Center (New York), the British Film Institute (London), the Institute of Contemporary Arts (London), ACMI (Australian Centre for the Moving Image) (Melbourne), the

Metrograph (New York), and many others—have run retrospectives of Wong Kar-wai films over the past few years, as Wong continues to command status as an auteur seemingly synonymous with Hong Kong cinema nostalgia. Recent releases by the Criterion Collection (releases by Criterion have been cited as being akin to "a Good Housekeeping seal of approval"[6]) include Ann Hui's *Boat People* (1982), a full remaster of Wong Kar-wai's entire film-ography, a rerelease of John Woo's *The Killer* (1989) back into the collection, Stanley Kwan's *Rouge* (1987), and Johnnie To's *Throw Down* (2004).

Wong Kar-wai's earlier works, with all their subliminal references to the political and historical (Wong is famously cagey about the political meaning of his films), now seem so obviously political that they are hard to deny. References start with He Zhiwu, the character in Wong's *Chungking Express* (1994) who obsesses over cans of pineapple, remarking that "everything comes with an expiry date." They continue in *Happy Together* (1997), Wong's first film made outside of Hong Kong and released in the year of the handover—a time marked by a wave of diaspora—in the form of a central character, Lai Yiu-fai (Tony Leung), whose name is a homonym in Cantonese for "you want to fly." Even the title of Wong's *2046* (2004) signals the year before the end of the fifty-year span of the "one country, two systems" agreement. As Lidija Haas argues about *Happy Together*, "The film was released with the subtitle

'A Story About Reunion,' giving its exploration of a long uneasy partnership a more openly political valence."[7]

Yet such a reading of Wong's films, as an allegory implying an anguished reunion between Hong Kong and China, seems less salient today. Considering his recent works in production—entailing script approvals for the series *Blossoms Shanghai* from state censors and a distribution partnership with state-run Tencent—the "political valence" in Wong's former work has become more elusive. In open cooperation with the state, these constraints mark a long-standing precedent in commercial Hong Kong film to meet the realities of state-regulated production and distribution at scale across the Sinophone market.

There is a tragic irony to the contemporary nostalgia for Hong Kong cinema of the 1980s and 1990s, which even in its time of production was already reflecting an ephemeral Hong Kong. It is as though such a feverish proliferation of retrospectives of this golden age of Hong Kong cinema only multiplies the nostalgia already inherent in the films, proving Ackbar Abbas's prescient *déjà disparu*—thirty years on, to marvel at a city calcified in time, stuck in an infinite filmic loop of nostalgia. Wong's early films consistently bring in such huge audiences today that there is a joke among some programmers that a recessive slump of ticket sales can be boosted by a weekend run of his films. And yet, his films are exemplary of a Hong Kong cinema "nostalgia overdrive":

the waves of retrospectives may be cyclical, but this particular elliptical cycle of global interest in Hong Kong cinema runs parallel to a dramatically different political moment for Hong Kong itself—and for new, working Hong Kong filmmakers.

For Randall Halle, there is a stultifying nostalgia plaguing cinephiles who attempt to "freeze" the canon and eulogize the past. Halle points to those who lock "European [cinema] in time and dismiss current production as not living up to past glories. Such nostalgia is itself a longing for forms that appeal . . . to static aesthetic criteria," which he aptly terms "the visual pleasure of viewing what one knows."[8] His challenge goes further:

> The desire to view according to static aesthetic criteria, however, reveals that an element of entertainment value has always adhered to high cultural production, that element that allows for a distance from the political and sociohistorical conditions with which each film struggles.[9]

It is notable that the current surge of interest in Hong Kong (and Taiwanese) cinema of this time is buoyed by an appetite from Asian American audiences for more representation. Rey Chow remarks on how Sinophone cinema since the 1980s has uniquely contended with having formed "an inherent part of a contemporary problematic of

becoming visible" within the cinema world at an international scale. Sinophone cinema, she argues, "has since the 1980s become an event with which the entire world has to reckon."[10]

These rereleases and retrospectives, all highly visible, run parallel to an unfolding present of political films post-2014 that are notably less visible: the more political the film, the less visible it is, and the auteurs of this new canon are notably less visible on the global stage. Further, with their original socio-historical undercurrents not fully appreciated, this contemporary "nostalgia overdrive" for Hong Kong cinema among global art-house audiences readily ossifies those Hong Kong films of the past—and their vision and representation of the city itself—into a canonical resin. With film censorship laws preventing local audiences today from seeing a new wave of Hong Kong cinema, the public that film spectatorship has long been considered to construct, whether mass, local, or even available, has become obsolete.

Nostalgia, as Rey Chow demonstrates, can be found throughout Sinophone cinema, and "the object of nostalgia—that which is remembered and longed for—often arguably takes the form of a concrete place, time, and event."[11] In contrast, Chow suggests, a different kind of nostalgia is present in Hong Kong films—specifically, Wong Kar-wai's: they are "not simply hankering after a specific historical past." Instead, "nostalgia in this case is no

longer an emotion attached to a concretely experienced, chronological past; rather it is attached to a fantasized state of oneness, to a time of absolute coupling and indifferentiation that may nonetheless appear in the guise of an intense, indeed delirious, memory."[12] Randall Halle further suggests that "such nostalgia . . . is not really for a film . . . but actually, perhaps paradoxically, nostalgia for a moment in which people were viewing things they did not know, when people were open to engagement with new aesthetic forms."[13]

Once upon a time, in the distant near past of the 1980s and 1990s, so passionate was the film culture of Hong Kong cinema that its audiences were known to slash the seats in the theater with knives in protest if a film did not meet their standards. In the current political climate, by contrast, there are no cinemas in Hong Kong that would show *Inside the Red Brick Wall* (Hong Kong Documentary Filmmakers, 2020), *Taking Back the Legislature* (Hong Kong Documentary Filmmakers, 2020), *If We Burn* (James Leong, 2023), or any other films that deal with or mention the protests in 2019. While the two works by Hong Kong Documentary Filmmakers mentioned above, for example, have been exhibited through festival premieres and limited screenings around the world, they have been barred from exhibition in their place of origin. Chan Tze-woon describes the process of sending his film *Blue Island* (2022) to get approval from the government censors:

he relates that "the Office for Film . . . has continually stalled the vetting of this film and I got no answer. I understand this delay as a prohibition from screening this film in Hong Kong even though I have no official response."[14]

Cinema after Place

Members of the Hong Kong diaspora (especially those in the most recent wave of emigrants, living in sites from the San Francisco Bay Area to Vancouver, Toronto, cities across the United Kingdom and Australia, or wherever the latest wave of the diaspora has arrived) are the audience for this new wave of Hong Kong cinema, at least the ones who can access these films, constituting a spectatorship that is located predominantly abroad. The films themselves become a critical means by which a politicized diaspora maintains a connection with place. The local audience is now legally prohibited from seeing some of the most daring films from Hong Kong today, but while the term "local" is typically used to describe a cultural context or origin, such films as *Blue Island* signal the construction of a new "Hong Kong public" dispersed by this diaspora. A counterpublic for new Hong Kong cinema, whether through clandestine, fugitive, or diasporic means, is being actively forged by new distribution channels within and beyond the local.

When the filmmakers, too, are displaced and self-exiled, or when their works cannot be shown in their place of origin, how can Hong Kong cinema be made and unmade, be understood "after place," severed from its locus of origin? Writing on a theory of Asian cinema that is relevant to such questions of geography, Stephen Teo observes:

> The notion of an Asian cinema is too vast a concept to be reduced to the question of its mere definition. Perhaps the central problem surrounding the problem of Asian cinema is an existential one: Is there such a thing as Asian cinema? Does it exist as a distinctive and unique entity, one which could be taught as an alternative model to Hollywood? . . . Asian cinema is viable only because it is a series of national cinemas.[15]

These same questions must also be asked of Hong Kong cinema. At face value, such questions might suggest a claim for the negation of Asian cinema, but instead Teo's provocation upends a conception of cinema as monolithic, as representative of the cultural production of a nation-state. Moreover, if Asian cinema is merely a collection of national cinemas, as Teo asserts, then the lens and domain of nationalism raises a core question for Hong Kong and also Taiwanese cinema, as cinema cultures that are distinctive and unique, from places that are

de facto countries. Teo boldly proposes that while "nationalism manifests as a monumental style . . . Asian Cinema is also a reaction against the national —a postnational conceit."[16]

The framework of the "postnational" offers a more productive lens through which to view Hong Kong cinema, both contemporary and past. Applying the "postnational" frame to Hong Kong cinema can be illuminating; if Asian cinema can be seen as an alternative to Hollywood, as Teo posits, it is also perhaps the case that the new Hong Kong cinema today is in the vanguard of such a move, as it reckons uniquely with the political and resists compatibility at both the territorial and national levels. What is Hong Kong cinema after place?

To release *Blue Island*, Chan Tze-woon resorted to screening the film exclusively overseas:

> We are now reaching out to diasporic Hong Kong communities and audiences located overseas, like the U.S. and Canada, for *Blue Island*. We are also working with distributors in North America and Japan. *Blue Island* was released in Japan in July this year. In September and October . . . in Europe. This is our strategy at the moment. We are trying to work on different plans in order to gain access to the people of Hong Kong as much as possible.[17]

New Hong Kong cinema cannot be theoretically confined simply by the national or even the territorial. When current laws prevent some of the most critical Hong Kong cinema made today from being seen by local audiences, an exilic or post-national framework is necessary to keep pace with new works and filmmakers.

History and Memory

What is the "Hong Kong" cathected through film, both past and present? The central project shared by parallel visions of Hong Kong—former and contemporary, narrative fiction and nonfiction documentary, commercial and independent—is that of how to encounter and (re)vivify the past through cinema. But how is it possible to move toward the past, especially the recent past, without a nostalgia tinged by sentimentality or an inherent longing for a fantasy? Chan Tze-woon's *Blue Island* offers up a unique challenge to Hong Kong cinema, contesting its former tropes of the sentimental and all of its nostalgic reckonings with the past. Crucially, Chan exits the dead end of nostalgia by constructing a gaze at the tableaux of the past with an equanimity that allows the anachronisms of history to surface unresolved—as unresolved as they remain today. It is in this smashing together of eras and forms that Chan creates, as if by atomic fission,

a voice for a truly present and unflinching Hong Kong cinema.

Chan Tze-woon was born in 1987, two years prior to the Tiananmen Square massacre of June 4, 1989 (or the "June 4 incident," as Beijing calls it). His early childhood thus spans the final ten years of British colonial rule. This biological fact is the prelude to Chan's first feature, *Yellowing* (2016), shot during 2014, which situates his generation's political "becoming" through the lens of that earlier period of history: beginning with the Hong Kong people's response to the Tiananmen Square massacre; the wave of diaspora out of Hong Kong that followed; his own family's decision to stay; his memories of the handover in 1997 when he was ten years old; learning "one country, two systems" in elementary school; and then studying basic law at university. By 2014, at the time of the Umbrella Movement, he was twenty-seven.

Chan thus belongs to a generation that has at least a nascent memory of colonial rule and an awareness of the transitional period, while also being sympathetic to the idealism of the younger generation, born after 1997, who in 2019 made up a significant demographic of protesters and student leaders and who honed an emerging and singular sense of what it means to be a Hong Konger. In *Yellowing*, Chan follows a group of protesters and friends in the Umbrella Movement. An attention to minor histories and a strategy of looking not at the

本來和我一起在天安門相處了很久
We spent a lot of time together in Tiananmen Square.

我一閉眼便看到那些同學
When I close my eyes, I see the students.

This page and previous page:
Chan Tze-woon, stills from
Blue Island, 2022.

events themselves but at their aftermaths, of focusing not on the leaders or the front-liners but on various people on the margins of the pages of history, is at the core of Chan Tze-woon's storytelling.

He first raises the question of what Hong Kong means to its people in *Yellowing*. "Many say that Hong Kong is a floating city," a voice-over in *Yellowing* begins, against a shot of Hong Kong from the perspective of a ferry gliding along the harbor. "Many of the older generation came here as refugees, treating 'here' merely as temporary shelter. This is the city in which I was born and bred." This opening sequence then unravels into a montage of harbor-front fireworks on October 1, National Day, intercut with shots of the 2014 anti-government protests, in which plumes of tear gas unfurl as the city fills with explosions, smoke, and yelling. These scenes become increasingly indistinguishable from one another, coin-flipping between national pride and resistance.

Focusing on the stories of lesser-known activists and protesters in the Umbrella Movement, *Yellowing* demonstrates Chan Tze-woon's interest in other ways of telling the story of social and political movements, an interest that will recur in *Blue Island*. The film ends with an image of a friend of his, sitting in the occupation in Central,[18] reflecting on the fear of betraying his political ideals:

> Am I afraid that I will be the same in twenty years? I don't know how I will become in

twenty years, but I hope I won't become such a person. But if I really become that, hit me hard and wake me up. So your film will become very important evidence to show me how I had been twenty years ago.

This last scene is particularly telling. It anticipates Chan's enduring interest in illustrating the complexity of Hong Kong's history across generations, ideological rule, and the energies of resistance that have persisted over periods of societal shift. In a critical foreshadowing of future events, another friend of his reflects, "We are young, we need to fight on." The events of 2019 pick up from these earlier unresolved energies and become a driving force in *Blue Island*.

It is important to note that—at a time when many filmmakers are working anonymously, have self-exiled to other countries, or have stayed in Hong Kong with the risk of being rearrested—*Blue Island* has been released under Chan Tze-woon's actual name, and that he continues to live in Hong Kong. In the opening of the film, an intertitle appears stating that the film was made possible through the support of 2,645 anonymous backers. Many of the names in the final credits of the film are either listed anonymously or are pseudonyms, and some names are even obscured with bars, denoting those who have been imprisoned. These imprints of the film's credits, marking redacted or incarcerated contributors,

elaborate on the risk and fugitivity present in new Hong Kong cinema. In watching the end credits, there is a sense that films like *Blue Island* could only have been made in the rapidly diminishing moment before many activists and oppositional law-makers were arrested or forced to self-exile. In this way, while the directors of films from Hong Kong's golden age dealt with political anxiety in their fictions through allegory, today's new Hong Kong cinema inherits and completes the tragedy of the city's history. This new generation of emerging Hong Kong filmmakers works against, and directly faces, the political risks that their predecessors foretold.

Doubling of Time

These hostile conditions have legacies. For much of the twentieth century, Hong Kong was the first port of asylum for many. Chan's method of storytelling often brings paradoxes and contrasts to the surface, leaving tensions between pairs of elements and counting on the viewer to thread the difference. This method places puncta throughout the film, wherein Chan contrasts two opposing events and draws connections between them: mainlanders fleeing to Hong Kong during the Cultural Revolution and Hong Kongers contemplating fleeing Hong Kong today; the Tiananmen Square massacre and the 2019 protests in Hong Kong; the 1967 riots and the 2019 protests.

Blue Island, shot over five years beginning in 2018, takes a hybrid approach to documentary, making use of Brechtian interruptions to stage tense dialogues that transcend the format of a reenactment.

Grander in scale, more poetic and ambitious than Chan's debut work, *Blue Island* begins with a shot of dense apartment blocks in Kowloon at night, animated by the sound of protest chants. These Cantonese slogans echo throughout the concrete apartment blocks filled with hundreds of units; in some shots, in the distance, there is the backdrop of the city's more globally iconic skyline. This montage then cuts to a distant shot of a prison, illuminated in the dark against a cliff face: the Hong Kong viewer can deduce that this is Stanley Prison, where many political prisoners are kept.

An intertitle provides context for the 2019 anti-extradition-bill, or anti-ELAB, protests and the National Security Law of 2020, stating that "among those affected were individuals documented in this film," an opening remarkably different in form from that of *Yellowing*. This time, Chan does not focus on bodies on the street in protest, like so many of the political documentaries being made at the time, but rather is interested in the aftermath of historical events and in how individuals, caught in the folds of upheaval, survive these paradigmatic shifts. The narrative technique of *Blue Island* weaves a radical historiography, animating and unsettling how one understands the key events in Hong Kong over the

past sixty years. Chan Tze-woon tells the story of a political crackdown on Hong Kong, viewing the force of time as tragically elliptical.

In these phantasmic returns to a near, and simultaneously more distant, past, Chan employs re-enactments to stage accounts of events, recruiting non-actors—many of them student activists of other eras who were themselves involved in the movements of their time—to play the figures in these scenes.

In the first of these vignettes, opening on a night scene in 1973, two refugees, a woman and a man, escape through the wilderness of southern Guangdong. They are heading for Hong Kong. As they reach the sea, shimmering in the moonlight, a light tower in the distance shines as a beacon in the dark. Tied to each other by a rope, with the woman wearing a flotation vest as well, they swim toward Hong Kong in the dark. The waves get louder, they submerge, and suddenly the film cuts abruptly to daylight: an elderly swimmer with goggles in the harbor of Hong Kong, swimming alongside ships, does a series of freestyle, breast-stroke, and butterfly strokes across the glittering ocean in the sun in the present day. "The agony he endured recurs from generation to generation," two students reflect; they perform in the reenactment sequence but now speak as themselves, out of charac-ter, looking at the water. They speak again: "Now that Hong Kong has come to this, have you ever thought of leaving?"

As the man emerges from the water, he is introduced as Chan Hak-chi, who "fled the Cultural Revolution in 1973." Next, Anson Sham, born in 1997 in Hong Kong, and Siu Ying, born in 1999 on the mainland, are introduced as students who were themselves involved in the 2019 movement, although the audience is not told to what extent. Cutting between the present day and historical reenactments, with voice-over of the students in conversation, Chan Tze-woon begins to blur the timelines as he brings the audience "backstage" to share the process by which he prepares each person to participate in the documentary reenactment. Anson Sham reveals that his father escaped to Hong Kong in the 1970s. Siu Ying's grandfather fled to Hong Kong, and after a lengthy process of applications he was able to get Siu Ying and the rest of her family to join him.

The clapping of a film slate introduces the next reenactment: a Communist Party assembly in the countryside in the 1970s, proselytizing the teachings of Mao. "Long live Chairman Mao! Hurrah!" With fists in the air, the crowd chants echoes back at the speaker, who has the famous Little Red Book in his hand. The film cuts to Chan Hak-chi, the swimmer, among the crowd. Anson Sham asks him, "Was the mood like this back then?" Smiling slightly, the present-day Chan Hak-chi responds, "No, not so fervent," and discusses the strategy of forced labor and reeducation camps during the Cultural Revolution. Anson Sham then asks, "What did you think Hong Kong was like?" Chan Hak-chi responds, "I thought

Hong Kong was a free place." Chan and his wife are then seen participating in the protests, holding hands and wearing black shirts. A montage of actors running through the mountainous region of southern Guangdong is intercut with shots of protesters running through the urban streets of Hong Kong.

As a channel promising freedom, a port of asylum, Hong Kong offered escape but also swallowed people whole. Chan Hak-chi next takes a ferry to an outer island for a memorial. Someone reads from a poem: "Anchors lifted, family forsaken. Never heard of again, grief surges endlessly. A slab stands today, mourning far and wide. Blessed was Hong Kong, marvel no more." Another voice chimes in: "Lost souls of the sea, our friends, can you hear us?"

As the camera pulls away, it reveals a small peninsula in the harbor, with docks and shipping containers in the background. An intertitle states: "50 years ago, 200,000 mainlanders fled to Hong Kong in the 1970s." Adjacent to this text, another reads, "As of today, 90,000 Hong Kong residents have left the city, since the National Security Law came into force." By telling the epic tale of decades of social upheaval not through nation-states, without elite activists as protagonists, and not even through singular events, but instead through a prolonged tableau illustrating ongoing resistance, political hopes, and failures, Chan's vision of political history in *Blue Island* is committed to the minor characters of history. Focused on people and events beyond the conspiracies,

cabals, and political intrigues that often dictate the newsworthy stories of social upheaval, he is interested instead in those who survive such upheaval.

A Melancholic Force

One question is in constant view throughout the film: "What does Hong Kong mean to you?" Siu Ying answers, "My sense of belonging in Hong Kong strengthened with the movement, but what I really love about this place, in the mainland I wouldn't emphasize—sure, I'd say I'd be Chinese, but I didn't feel a sense of belonging to the community." Anson Sham answers, "I know Hong Kong tried its best to resist decay. But attempting to defy fate seems futile. To me, I want to help my hometown. I feel for this place and its people." In response to whether he has thought of leaving Hong Kong, he replies, "I think Hong Kong, to me, is my family." The students who play the subjects—the original social actors—in the reenactments take on a performance that becomes entwined with and nearly indistinguishable from how they view their own lives and city today.

Blue Island is a title that points at Hong Kong's identity as a port city, a metropolis that contains generations of disenchantment, disappointment, and political melancholia. It suggests that citizens of this city have been caught in the turns of successive hegemonic powers and upheavals, unable

to determine their own fates. In response to each wave of change, each generation merely endures—like a relentless swimmer in a vast ocean.

The vignettes woven through *Blue Island* make a point about the recurrence of history and raise critical questions regarding our ability to understand events only after they unfold. Reflecting on the prevalence of live-streaming the protests, and how their audience and its influence on the social movement was unique, Chan Tze-woon has remarked on how his approach with *Blue Island* was obliged to acknowledge the limits of what his camera was able to do in the face of such real-time video.[19] Chan's interest, by contrast, is in the aftermath of events and of 2019, looking at what happened in the days that followed the apogee of political becoming.

The film's second vignette stages a reenactment of a family gathered around a television, watching news of the Tiananmen Square protests; this is interwoven with archival footage of Hong Kongers marching in solidarity in 1989. In Cantonese, the following chants intone: "We support the people of China"; "Long live the solidarity of all overseas Chinese across the world"; "Down with autocracy"; and "Down with Li Peng." In the streets of Hong Kong, protesters from 1989 sing the Chinese national anthem: "Braving the enemy's fire, march on!" The lyrics resound with tragic irony as the massacre of Tiananmen Square follows. Students scramble amid smoke and gunfire and the blood of their comrades.

These scenes, entwined with footage of the crackdown on the 2019 vigil for Tiananmen held in Victoria Park, in Hong Kong, introduce the next protagonists: Keith Fong Chung-yin is a student representative in the 2019 protests who is awaiting trial; since the film's release, he has been sentenced to nine months in jail for being seen purchasing laser pointers. Kenneth Lam is a survivor of the Tiananmen Square massacre who now works as a lawyer and advocate.

In reenacting the massacre, Keith Fong Chung-yin at first delivers a stilted monologue. Chan Tze-woon suggests that his crew show him the original video of the television interview with Lam again, and coaches Keith Fong: "See if you can't project your own experiences into the character. You're not just playing a twenty-year-old Lam in the '80s. You are also playing yourself." His performance is uncanny. Later Fong, as himself, confesses: "I was always prepared to be arrested. I've been expecting it since I ran for student union." The film then cuts to Lam in his law office today; amid his piles of papers, there are personal pictures of the 1989 events.

Debt and Ruptures

A heartbreaking party scene unfolds. At a gathering for the Hong Kong Federation of Students' sixtieth anniversary in a bustling banquet hall, Lam is seen

among colleagues and activists. On the stage, he gives a speech, addressing the room:

> When we were young we dreamt of a better world. I never expected to know the meaning of "shattered faith." Let me tell you, 1989 was such a historic movement. In its aftermath, the world plunged into deeper darkness. I fell asleep and refused to wake up at the Federation of Students, because I didn't want to face reality.

One of the people he speaks to at the party is an individual working on the Hong Kong–Zhuhai–Macau bridge, who beams with excitement over the promise of a rising GDP thanks to infrastructure from the Belt and Road Initiative. He also speaks to others about the Occupy Central 9 case:[20] even though they have the best lawyers for their defense, they have no strategy. "The charges [the government] laid are carefully chosen," Lam says to a group of younger individuals. "Since the '90s, we have felt like deserters. I felt I needed to take care of myself and my family first before doing what was my duty. I often felt that this was a bit lacking. So when I see you guys, I feel very ashamed."

As Kenneth Lam makes his way through the party, a few younger faces emerge, with subtitles introducing them: Lester Shum, awaiting trial since January 2021; Leo Tang, sentenced to four months in

prison in 2020; Nathan Lau, awaiting trial since January 2021; Benny Tai, one of those convicted in the Occupy Central 9 case, awaiting trial since January 2021; and Au Nok-hin, awaiting trial since January 2021. Lam confesses to Tang on behalf of his generation, as theirs is fighting on the streets, "We owe you too much." Lam's admission is tragic, as though to suggest that his generation's failed resistance produced the historical debt that has been deferred to the next—in this case, their grandchildren. The presence of these intertitles and their silence—Chan chooses not to interrupt these scenes—is haunting.

Amid the loudness in the room, the events that this scene foreshadows underline the ongoing tectonic shifts in the social and political landscape that undergirds everyone there. This moment of togetherness is convivial but fleeting. Dread is palpable. In a later sequence, after gathering around a street corner next to a police station, Lam and his comrades from 1989 perform a ritualistic burning of Taoist papers for the dead in memory of Tiananmen, and a fellow survivor asks Lam, "Do you think all those people who came back from Tiananmen became lonely souls? I didn't think so at first, but as time went by . . ." She trails off. Flames flicker in the wind as a sequence of old photographs of Lam and his comrades in Beijing emerges, apparitions from the past of their lost political ideals.

The realities involved in sustaining and pursuing political ideals raise questions that Chan

Tze-woon began to consider in *Yellowing* through a conversation between a son and his parents. Upon learning that his son is participating in the protests, the interviewee's father says, "I am passionate but I also need to feed myself." Caught between ideals and pragmatism, the father laments, "Strike is very difficult if you have to support a family. I want to participate, but I need to pay my mortgage and support my kids." Such concerns, weighing the pragmatism of resistance, are left open-ended in *Yellowing*, but Chan returns to them again in *Blue Island*. Who can afford to live out their political ideals? And what price must they pay?

Chan's method of telling history embraces a radical equanimity that resists any attempt to adjudicate one's role in it. As if to demonstrate that knowing this history without flinching from its paradoxes might be the only route to understanding it better, eschewing all attachment to fantasies and conventional modes of narrating the past, Chan immerses the viewer in a speculative temporal stage wherein all of his protagonists, subjects as well as actors, can reckon with the loss of others—as well as their own losses, past or present or future. As Bill Nichols has argued, documentary can offer the viewer a unique space of mourning:

> The attempt to conjure that specter, to make good that loss, signals the mark of desire. What constitutes a lost object is as various as

all the objects toward which desire may flow. . . . In other cases, the working-through of loss need not entail mourning; it can also, via what we might call the fantasmatic project, offer gratification, of a highly distinct kind.[21]

The works by Hong Kong Documentary Filmmakers picture a fugitivity in filmmaking that confronts the dispossession of a subject on camera in revolt.[22] In contrast to their directness, Chan Tze-woon's *Blue Island* takes a different route: a reliance on reenactment as a means of possessing the past. This use of reenactment creates a hybrid form that renders "the past to new ends," where life and performance blur, where something else emerges.[23] As Dennis Lim observes in another context, inherent in cinema is a strong "kinship between ghosts and movies. Premised on illusion and promising endless reanimation, cinema has been called the ghostliest of mediums. Ghosts represent unfinished business, the persistence of the past."[24] Chan invites a fantasmatic contrivance of past and present to come into dramatic collision, wherein loss, memory, and political ideals are processed on-screen through historical reenactment. Historical memory and the unknown present converge, allowing the subjects of the film—those who have lived through pivotal events of the last century—to reckon with the insoluble feelings that persist through history. History's residue is made up of these aftermaths and recollections that cannot be put to rest.

In one scene—still wearing the costume he wore while playing Kenneth Lam in an earlier re-enactment, the banners of Tiananmen hanging behind him—Keith Fong reflects in a conversation with Chan Tze-woon, "I think the dream of a democratic China died on the night of June 4. So what about Hong Kong? I want it to have a democratic, free—or a government that answers to Hong Kong people." Chan asks him, "Do you think that's achievable? Will you see it in your lifetime?" Keith Fong looks off into the distance without answering.

Tableaux of Revolt

Directing activists in constructed historical scenarios, Chan brings parallels and paradoxes to the surface, moving between political ideals and their realities. Telling such a complex history of endurance without giving in to nihilism, fatalism, or any simple reactionary conclusion, Chan attends to each event in history by weaving his way from historical point to point in order to elucidate the tensions involved in enduring time itself.

While the first two vignettes depict a persistent history of political refugees fleeing persecution from the CCP (Chinese Communist Party), where comparisons between the history of the twentieth and twenty-first centuries are relatively compatible, such historical comparisons begin to rupture as the

film slips into the highly contentious territory of its last and most dynamic story of contrasts. Drawing comparisons between the 1967 riots and the 2019 protests, *Blue Island* addresses the ideological paradoxes inherent in the history of resistance in Hong Kong over the last century.

The prevailing language used in reference to these two events—"riots" versus "protests"—speaks to differing opinions in popular memory. As historians Ray Yep and Robert Bickers point out, the use of "the term, 'riots' (*baodong*), carries negative connotations of violence, wantonness and destruction, as it does in English. . . . The collective memory of the event as 'riots' reflects widespread popular contempt and condemnation of the disturbances that took place in 1967. Chinese public opinion was clearly on the side of the colonial administration in 1967" due to a campaign of bombings and fifty-one deaths.[25] As Yep argues: "The crisis sparked by the anti-colonial riots in 1967 is arguably the most important historic episode of the colonial history of Hong Kong in the post-war era."[26]

Yet, despite its significance, Yep and Bickers observe that the historiography of this event is challenging, with many accounts seen as "partisan" or "journalistic."[27] Moreover, "the public representation of these months of conflict is muted—there is little mention of them in the Hong Kong Museum of History, and most works on post-war history of Hong Kong allocate no more than a few pages on

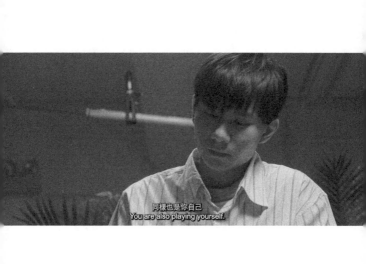
同樣也是你自己
You are also playing yourself.

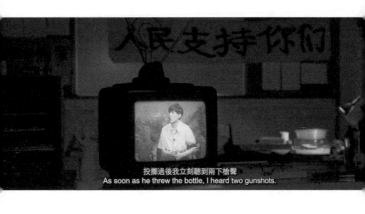

投擲過後我立刻聽到兩下槍聲
As soon as he threw the bottle, I heard two gunshots.

This page and previous page:
Chan Tze-woon, stills from
Blue Island, 2022.

this subject."[28] On the other hand, there was a mass concerted effort in 2019 for protesters to resist the label of "rioters," since the term was often used in press conferences held by Chief Executive Carrie Lam or the police, with a popular protest chant insisting: "No rioters, only tyranny."

This context of a highly contested history, only partially processed, of leftist revolt is what Chan Tze-woon invokes by pairing two activists in his final vignette: Raymond Young, a leftist activist who was charged with subversion for publishing an anti-colonial bulletin in the 1960s, and Kelvin Tam Kwan-long, a 2019 protester charged with rioting. Kelvin Tam, facing a sentence of ten years, contemplates the time ahead of him as he sits in a cell with Young in this reenactment; Young was jailed in the 1960s for eighteen months for writing, printing, and circulating an anti-colonial bulletin. Taking in his fate, Kelvin Tam focuses on the three concrete walls around him. Young understands himself as Chinese, and sees his act as righteous and nationalistic, while Tam identifies as a Hong Konger and stands explicitly against the CCP. Despite their political differences, which could frame their positions as ideological opposites, Young offers Tam perspective on what is to come, remarking:

> Time is the greatest test. Time will slowly erode your ideals. Especially when you see others who were in the movement with you,

they may or may not be leaders. Some will flee, some will be in power. And some will forget their aspirations and ideals. Imagine what your comrades will be like forty-five years from now. In fact, most of us have been abandoned.

Young proposes that they are both the "abandoned kids of the riot." As a leftist dissident, Young is a complicated character. Since his sentence, he has become a highly successful businessman, living in a large house overlooking one of the most exclusive neighborhoods in Hong Kong, Repulse Bay. He asks: "We, the people of Hong Kong, across our 150-year history—have we ever been able to control our own fate? No, we have always been at the whim of fate."

A central theme that occupies the work of Chan Tze-woon, whether in *Blue Island* or *Yellowing*, is how individuals meet the fate of time, and how political ideals meet their test.

What many of the characters in these vignettes have in common is their status as survivors of significant historical events; while some may be known, others are not. Chan brings a challenge: how to grapple with historical subjects on-screen, how to account for histories of revolt outside of the West that demand an attention to the inconveniences of a narrative that encompasses plains of resistance over successive eras.

In Hong Kong, the history of even a democratic left is often made minor. Tom Cunliffe observes, "In the wake of the recent 2019 uprising and implementation of the National Security Law, the labor activist Au Loong-yu recently wrote that if there is any possibility of a democratic left in Hong Kong today, the histories of earlier waves of leftists in Hong Kong (including *The 70's Biweekly* collective) must be taken into account."[29]

Blue Island questions how the complicated historical process of revolt in such places as Hong Kong can be made legible—by resisting sound bites and Cold War binaries of ideology, by attempting a third way. Possibly this is a narrative that, in the words of Fadi A. Bardawil, breaks the "deadlock of having to choose between authoritarian nationalists and imperial democrats," wherein the "long eclipsed subject and agent of emancipation—the people—[occupy] center stage again."[30] Perhaps it is a narrative that recognizes how the so-called abandoned kids of the riot were also the ones who believed in the riot, as well as the protest, as ways of transforming history.

Entangled Ends

While Chan Tze-woon raises these questions about ideology in his film, it is precisely their unresolved tensions that are *Blue Island*'s strength. His method is such an interesting model for political film. In a

time when so many films coming out of Hong Kong depict the protests to attempt to make their case, the work of Chan Tze-woon raises questions about what audiences should expect from political cinema. Resisting the expectation to merely meet the audience's desire for being validated or lectured to, and abstaining from any moralizing narration, Chan here engages with a more unsightly subject: tableaux of revolt, uprisings, and the messiness of political evolution. Avoiding the swell of optimism, idealism, or hope, Chan faithfully attends instead to the aftermath of such events, even to disenchantment and disillusionment in the wake of ongoing catastrophe, and the energies necessary to sustain resistance and survival over time.

The final scenes of *Blue Island* bring the device of reenactments into the courtroom. In a doubling of time, reenacting his own appeal for the film, Eason Chung, one of the Occupy Central 9, reads his speech before his sentencing:

> We refused to be subservient to provisions, to authority, and to institutions. We want to venture into an unknown world. A world where history and the present are entangled, where individual endeavors interact with unanticipated turns of events. . . . I have no need to make an appeal here today. All of us sitting here today have a responsibility to step out of this courtroom, out of the legisla-

ture, out of the media landscape. To leave behind all intermediaries and get to know the world in person. To experience the world ourselves. None of this can be explained in this courtroom.

Following that speech, the final scene of *Blue Island* is silent: a montage of individuals sitting in the courtroom, looking back at the camera. Intertitles appear once again, noting the individuals' professions as "activist," "community organizer," "clerk," "district counselor," "YouTuber," "delivery-man," "fitness center owner," etc., along with their sentences and charges. Some faces are recognizable; others are those of ordinary people. The sequence is a disquieting reminder of a scale that cannot be captured on film: the thousands awaiting trial, waiting to be charged, or awaiting sentencing. The sequence is intentionally overlong, in order to impose a durational rhythm that echoes the systematic and less visible process of legal and carceral attrition, which is prolonged and exhaustive.

Expanding on a notion of accented cinema, or exilic and diasporic cinema, it is not just filmmakers or artists themselves, but their work—films as vehicles for ideas and their audiences—that are rendered exilic under hostile conditions. Given the challenge of viewing new Hong Kong cinema today, audiences can now be guided by Chan Tze-woon's *Blue Island* toward central questions of how to

engage with the past. What to seek out of the past to tell the present? Are such fabulations through the moving image driven by a melancholic attachment to a former time? Is it possible to seek a past to redeem the present? Or is this a search to redeem the past? Such questions about the aftermaths of history —and their unresolved feelings and tensions— are live and ongoing, and are being taken up by a new generation of Hong Kong filmmakers today.

Amplified by its indelible imprint on global cinema, and despite its small geographic size, Hong Kong has often found itself at the nexus of global history. If one looks hard enough, one finds mention of Hong Kong in seemingly unexpected places.[31] Even James Baldwin wrote about Hong Kong once, speaking of himself only in the plural, and with a voice seemingly out of time. His words offer a fitting epigraph:

> In that darkness of rape and degradation, that fine flying froth and mist of blood, through all that terror and in all that helplessness, a living soul moved and refused to die. We really emptied oceans with a home-made spoon and tore down mountains with our hands. And if love was in Hong Kong, we learned how to swim.[32]

Notes

1. Ackbar Abbas, "The New Hong Kong Cinema and the *Déjà Disparu*," *Discourse* 16, no. 3 (Spring 1994): 66.

2. Abbas, 66.

3. Daniel Chan, David Chan, Crystal Chow, and Rex Ren, "Hong Kong Free Cinema Manifesto," trans. Daniel Chan and Tom Cunliffe, *Film Quarterly*, June 16, 2023, filmquarterly.org/2023/06/16/hong-kong -free-cinema-manifesto/.

4. Mette Hjort, "Introduction: The Film Phenomenon and How Risk Pervades It," in *Film and Risk*, ed. Mette Hjort (Detroit, MI: Wayne State University Press, 2013), 12–13.

5. Chan et al., "Hong Kong Free Cinema Manifesto."

6. Kyle Buchanan and Reggie Ugwu, "How the Criterion Collection Crops Out African-American Directors," *New York Times*, August 20, 2020, nytimes.com /interactive/2020/08/20/movies/criterion -collection-african-americans.html.

7. Lidija Haas, "Wong Kar-wai's Masterpieces of Political Uncertainty," *New Republic*, December 2, 2020, newrepublic .com/article/160315/wong-kar-wai -masterpieces- political-uncertainty-review.

8. Randall Halle, "History Is Not a Matter of Generations: Interview with Harun Farocki," *Camera Obscura* 16, no. 1 (46) (May 2001): 49.

9. Halle, 49.

10. Rey Chow, *Sentimental Fabulations, Contemporary Chinese Films: Attachment in the Age of Global Visibility* (New York: Columbia University Press, 2007), 14.

11. Chow, 52.

12. Chow, 51–52.

13. Halle, "History Is Not a Matter of Generations," 49.

14. Quoted in Tiffany Sia, Emilie Sin Yi Choi, and Chan Tze-woon, "Three Hongkongers on Making Documentary Film under the Gaze of the State," *Artnet News*, September 14, 2022, news.artnet.com /opinion/making-documentary-under-the -gaze-of-the-state-2176000.

15. Stephen Teo, "Asian Cinematic Practice: Towards an Alternative Paradigm" (paper presented at the international conference organized by the Asia Research Institute [ARI] of the National University of Singapore, March 6–7, 2007).

16. Stephen Teo, *The Asian Cinema Experience: Styles, Spaces, Theory* (New York: Routledge, 2013), 11, 15.

17. Sia, Choi, and Chan, "Making Documentary Film."

18. Central is the name of the heart of the financial district in Hong Kong, where many occupations and protests took place in 2019, as well as during the Umbrella Revolution in 2014.

19. Sia, Choi, and Chan, "Making Documentary Film."

20. Occupy Central 9 refers to the nine democracy advocates who were tried and convicted for their roles in the 2014 Umbrella Movement: law professor Benny Tai Yiu-ting, sociology professor Chan Kin-man, Baptist minister Chu Yiu-ming, Legislative Council members Tanya Chan and Shiu Ka-chun, former student leaders Tommy Cheung and Eason Chung, social activist Raphael Wong, and public servant Lee Wing-tat.

21. Bill Nichols, "Documentary Reenactment and the Fantasmatic Subject," *Critical Inquiry* 35, no. 1 (Autumn 2008): 74.

22. For more on the Hong Kong Documentary Filmmakers and their work, see Tiffany Sia, "Phantasms of Dissent: Hong Kong's New Documentary Vernacular," in this volume, 45–80.

23. Nichols, "Documentary Reenactment," 74.

24. Dennis Lim, "*Rouge*: Love Out of Time," June 21, 2022, Criterion Collection, criterion.com/current/posts /7833-rouge-love-out-of-time.

25. Robert Bickers and Ray Yep, eds., *May Days in Hong Kong: Riot and Emergency in 1967* (Hong Kong: Hong Kong University Press, 2009), 3–4.

26. Ray Yep, "The 1967 Riots in Hong Kong: The Domestic and Diplomatic Fronts of the Governor," in Bickers and Yep, *May Days*, 21.

27. Bickers and Yep, *May Days*, 2.

28. Bickers and Yep, 1.

29. Tom Cunliffe, "Documenting Anti-colonial Social Movements in Early 1970s Hong Kong with 16mm," *JCMS: Journal of Cinema and Media Studies* 62, no. 2 (Winter 2023): 176.

30. Fadi A. Bardawil, *Revolution and Disenchantment: Arab Marxism and the Binds of Emancipation* (Durham, NC: Duke University Press, 2020), xv.

31. In Laura Poitras's film *Citizenfour* (2014), for instance, filmed five years prior to the protests of 2019 that were ignited by the extradition bill, Edward Snowden wonders aloud to his lawyer, in one uncannily prescient scene: "Is there precedent for this, where Hong Kong would extradite someone for political speech?"

32. James Baldwin, "Nothing Personal," *Contributions in Black Studies* 6 (September 2008): 12. Originally published in Richard Avedon and James Baldwin, *Nothing Personal* (New York: Atheneum, 1964).

Toward the Invisible

My talk today centers on a blank image. Not a glitch or a technical failure. This blank image begins as a provocation, reflecting upon the open question of the category of "Asian American": a two-headed paradox of geography, entwining Asia and the United States.

I open with a quote from Susette Min's book *Unnamable: The Ends of Asian American Art*, in which she ponders the very predicament posed for the scholar and curator who confronts the term:

> The Asian American curator is now burdened with the task of brokering and preserving works of Asian American art. Under pressure to racially profile and filter, discover and display a diverse array of "new" Asian American artists, and at the same time to link older artworks to a historical avant-garde or to some other received art-historical tradition in order to maintain upkeep and increase the value of such works, I am, as a curator and writer about Asian American art, experiencing a disquieting ambivalence.[1]

I share this ambivalence as I'm invited to join this incredibly illustrious group of scholars and artists today, with whom I'm so honored to be in dialogue over the course of this seminar. It's an intense privilege to be in such a room.

Yet this sense of gratitude and honor is twinned with an open reluctance toward accepting such an invitation: What project are we building together? Can an aesthetic and a consensus of politics be assumed or formed through identity? Is it simply enough to *see* ourselves as subjects in a Hollywood film, for instance, or as subjects of artworks in a major American museum—two attempts to repair our historical exclusion from the American public or a national canon? Conscripted to reform American nationalism through multiculturalism, how do we not risk defanging the politics of artworks through canonization? Or become accomplices in renewing the legitimacy of the institution at large? In the words of historian Lisa Lowe, "The production of multiculturalism at once 'forgets' history and, in this forgetting, exacerbates a contradiction between the concentration of capital within a dominant class group and the unattended conditions of a working class increasingly made up of heterogeneous immigrant, racial, and ethnic groups."[2]

To deconstruct the category of Asian American art and aesthetics, let's return to the two-headed paradox of Asia and America. As Gordon Chang writes, "Upwards of twenty thousand Chinese, 90 percent of the CPRR construction labor force, had built almost the entire western half of the Pacific Railway," and many were workers who came through the Pearl River Delta to California.[3] Hundreds of Chinese workers were also hired to

help construct Stanford University on the unceded ancestral land of the Muwekma Ohlone people. These facts constitute the material history of the Asian worker, conscripted to construct the nation and the institution. The material framework that houses such a discussion today is undoubtedly a fraught one, and for me, it undergirds this next question: How might the contours we draw around our own belonging to this country and to the American canon, as artists and scholars, underline a settler logic that obscures Indigenous sovereignty —and potentially misses altogether, amid critical conversations about colonialism, the simultaneities and densities of colonial history in relation to the American empire? In the words of friends and collaborators Adam Khalil, Zack Khalil, and Jackson Polys, core members of New Red Order, a public secret society with rotating membership: *Feel at Home Here.*[4] A title as an anti-colonial provocation; a sinister dare.

On the other head of this double-headed paradox of "Asian American" as a category: Where, for us, does Asia begin?[5] Does it begin in Palestine? After all, Edward Said—the author of such a monumental work for the fields of Asian studies and Asian American studies as *Orientalism*—is a Palestinian intellectual. And on the other end, does our definition of Asia include Australia and Hawai'i? If the definition of Asian American identity opens up a discourse about solidarity, where might we locate

the bounds of our relations? Moreover, when we talk about Asian studies or Asian American studies, we must reckon with how often such frameworks disproportionately center East Asia, obscuring the epistemologies and histories of South Asia and Southeast Asia. The questions I'm asking here many scholars and artists in this same room have asked for decades, but such questions endure and must also be reframed in new times. And as ever, it is dizzying to traverse the expanse of time, space, and many-headed consciousness that the term "Asian American" asks us to imagine.

Geography resides at the heart of these riddles. Perhaps, when thinking about the title of Lisa Lowe's book *The Intimacies of Four Continents*, we might think of how colonialism, as it were, wrought the intimacies of these histories through violence, trade, and war. Yet there is an opposing interpretation of Lowe's title that also feels salient: that colonialism and the project of liberal area studies posit the profound *alienation* of the four continents (Europe, Africa, Asia, and the Americas), as well as the amnesia and severance of histories through war, displacement, and assimilation. As Asian Americans, what is our physical and conceptual distance to Asia? What are our own fantasies about Asia? As Grace En-Yi Ting observes, "With its Cold War origins and ongoing struggle to grapple with questions of race and imperialism, Asian studies might feel like a less than likely site for radical

solutions."[6] Anyway, what does such categorization vis-à-vis area studies achieve? While some might categorize me as a Hong Kong artist—or maybe even boldly as a Chinese artist—others might deem me an American artist. Others still might exclude me from these labels altogether. In the end, what narratives does any such label serve?

I am interested in flipping this coin of visibility and invisibility. The provocation of a black/blank image attempts to summon a political imagination toward the unseeable, the unarchived, the inconvenient, or the contradictory. If identity politics is, in the words of Michael Warner, "a way of overcoming both the denial of public existence that is so often the form of domination and the incoherence of the experience that domination creates," how might we claim or produce different forms of public existence?[7] This image, as gesture, owes acknowledgment to lineages of Black art and abstraction, as described by Darby English in *How to See a Work of Art in Total Darkness*:

> For in order to be visible or understood as a work of art, black art must concede some involvement with the conceptual, linguistic, and historical means by which something becomes so visible or understood. . . . [I imagine] the history of black art in America as an institution of refusal, too frequently bent on ordering, as a distinct series, a range

of phenomena that, when approached differently, enable us to discover chance, the discontinuous, and materiality at their very roots.[8]

How can thinking beyond visibility open up an aperture to alternate methodologies? Or perhaps attend, as it were, to other forms of radical methodology through an attunement to ghostly presences in history, beyond any singular standardized telling that might obscure another? What are other methods, beyond simply summoning ourselves, that might be mobilized to materialize a cultural formation, or restless histories, in experimental forms? To embrace incoherence? Beyond the permissions of genre, nation, or institution, this blank image as form withholds information as much as it offers a space of contestation. This image is meant to confront absence as much as to reorient us through a material that is both blank and black, empty and dense, concealing information as much as it is reflexive.

This blank image is, in fact, taken from my latest short film, *What Rules the Invisible* (2022), which takes amateur travelogue footage of Hong Kong shot around the city between the 1930s and 1970s and juxtaposes it with intertitles of my mother retelling her memories as a child of postwar Hong Kong. Soundtracked by the sounds of cicadas, the short adopts the rhythm of a silent film: Image, image, image. Text. Image, image, image. Text.

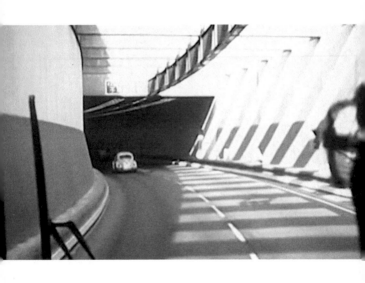

This page and previous page:
Tiffany Sia, stills from *What Rules the Invisible*, 2022.

My mom's retellings are rendered in bold: ghosts of prisoners of war from the Japanese occupation haunting the police stations; Sikhs who were con-scripted by the British as a way of deflecting anti-colonial sentiment; the sanitary worker who made regular rounds to dump out pots of excrement in lieu of plumbing. In dizzying juxtaposition, travel-ogue home movies—more idyllic and more common in the global popular memory of Hong Kong—appear vividly. Such scenes are familiar, clichéd even: junk boats at sea; scenes of busy commuters shuf-fling in the streets; high-rises in dramatic relief against a landscape of mountains. Alongside these images, myth and superstition become vessels that contain the memory of violence and colonial history, memories that are absent in the images but alive in oral history. In *What Rules the Invisible*, montage becomes a method by which to force the viewer to hold an active tension between the gaze of travelogue home movies and my mother's childhood recollections of an adult world, a residue of history that she was just learning—a space between image and absence.

An-My Lê once reflected: "The . . . camera has provided me with multiple shields from the painful memory of war, while allowing me to come as close as possible to try to understand it."[9] Learning the translation of the term 賣豬仔 while writing the artist book *Too Salty Too Wet* in 2020 helped me understand that my great-grandfather was sold,

along with his two brothers, as a coolie from the Chinese province of Fujian to the Malay Peninsula to work in open-pit tin mining. This fact was occluded or obscured by shame or translation, yet more riddles remain in my lineage. And another: Born on October 1, 1949, my dad was adopted. For decades we didn't know his family, until I recently found his biological father, an Italian American US naval officer who was stationed in Shanghai in the 1940s and later died in Okinawa after fighting in the Korean War. My grandfather is buried in the national cemetery on Long Island, within an hour of where I currently live. His picture sits on my dresser. It is my own family history that exceeds the coherent, and that perhaps explains the root of my own intense skepticism toward categorization based on any modern notion of geography or place. To tell the story of my lineage requires slipping across countries and continents; it goes beyond a naturalized vision of history or a singular national or continental framework. It is the story of port cities fluctuating between cycles of dispossession and affluence, cities where people and materials were bound by brutality even as they were entwined through intimacy.

Flipping the coin of visibility and invisibility, of legibility and illegibility, of the empty and the dense, this blank image is a placeholder for a cultural category that begs to exceed geography and nationalism, that goes against the monumental

and beyond the figurative or slick narrative, beyond genre, on its own inconvenient, restless, and bastard terms.

An earlier version of this essay was presented as part of the "Art Activisms" panel curated by Howie Chen at the IMU UR2: Art, Aesthetics, and Asian America symposium on October 28, 2022, at the Cantor Arts Center, Stanford University, California. Other speakers on the panel included Howie Chen, Nancy Hom, Arlan Huang, and respondent Gordon Chang. The prompt was to give a talk on a chosen image for ten minutes.

Notes

1. Susette Min, *Unnamable: The Ends of Asian American Art* (New York: New York University Press, 2019), 13.

2. Lisa Lowe, *Immigrant Acts: On Asian American Cultural Politics* (Durham, NC: Duke University Press, 1996), 86.

3. Gordon H. Chang, *Ghosts of Gold Mountain: The Epic Story of the Chinese Who Built the Transcontinental Railroad* (Boston: Houghton Mifflin Harcourt, 2019), 2–3.

4. This was the title of New Red Order's exhibition at Artists Space, New York, May 19–August 21, 2021.

5. See Astria Suparak's ongoing series *Asian Futures, Without Asians* (2020–), astriasuparak.com/2020/02/13/asian-futures-without-asians.

6. Grace En-Yi Ting, "Minor Intimacies of Japanese Literature: Calling Out into the World in Times of Trauma," *eikon*, positionspolitics.org/minor-intimacies-of-japanese-literature/.

7. Michael Warner, *Publics and Counterpublics* (New York: Zone Books, 2002), 26.

8. Darby English, *How to See a Work of Art in Total Darkness* (Cambridge, MA: MIT Press, 2010), 8–9.

9. An-My Lê, quoted in HG Masters, "An-My Lê: Theater of Observation," *ArtAsiaPacific*, no. 60 (September–October 2008): 170–79.

No Place

Some of the most personally exciting and inspiring encounters happen only if they spill over from the stage, in private exchanges and off-the-record conversations. Last fall, at a symposium on Asian American art and aesthetics, I had the chance to meet historian Gordon H. Chang. The author of *Ghosts of Gold Mountain* (2019), Chang has researched and written about the lives of Chinese coolie labor in the United States.[1] In the absence of even a single primary account from a coolie, his monumental work of historiography summons these apparitional, unknown figures who constructed roughly seven hundred thousand miles of train track for the Central Pacific Railroad (CPRR) between Sacramento, California, and Promontory, Utah. By itemizing shipping manifests, studying the types of food imported and games played, and analyzing accounts kept by those overseeing the CPRR project, Chang assembled a makeshift historical picture of the lives of these Chinese laborers. Coolies, many of whom were transported from Fujian and other Chinese provinces, risked injury or death due to treacherous ascents on cliff faces and the explosive demolition of rocks in the Sierra Nevadas as they hung from suspended baskets—though even this detail is uncertain. Coolie laborers worked through all seasons to make way for this behemoth infrastructure project, an undertaking that was as violent as it was foundational, shattering Indigenous land and territory and blasting across the sublime landscape.

Over dinner, curator and scholar Howie Chen, Gordon Chang, and I discussed art and politics, the limits and potentials of political art, and differing notions of activism across generations. For me, most excitingly, we talked about the inconvenience of oral history.[2] Turning to Gordon as though he were some kind of tarot or palm reader, I shared my own family history. Although my great-grandfather left no diary, my family inherited some piecemeal stories. One of three coolie brothers from the province of Fujian, he was sold in a package deal to the owner of a tin mine in a Southeast Asian territory of the Malay Peninsula. We don't know much about the time he and his brothers spent working in the mine, and have only a cluster of facts: Desperate to leave Fujian, they were enticed by free passage to the Malay Peninsula in exchange for their labor. After they had earned their freedom back, they exchanged their wages for a barren parcel of land at the mine they worked on. I also told Gordon the story of my biological grandfather, an American born in Red Hook, Brooklyn, who was stationed as a sailor in Shanghai in the late 1940s. When he left Shanghai to fight in the Korean War, he gave my grandmother two gold plates and instructed her to meet him in either Taiwan or Hong Kong. My biological grandfather later died in Okinawa, Japan. His son—my father, Andrew—was born on October 1, 1949, the founding day of the People's Republic of China (we suspect the date to be a false birthday). Andrew

was adopted as a baby. My adoptive grandfather raised my father in the French Concession in Shanghai. A communist sympathizer with ties to founding members of opposing political groups, this grandfather became the target of covert nightly interrogations. He ended up, I suspect, ensnared in the fold of early violent ideological taxonomies that transpired prior to the broader public campaigns of the Cultural Revolution that would follow years later. Historiographies assembled in national archives provide some context for me to understand this loose chain of history, but leave much up to guesswork.

"As a historian," I asked Gordon, "how do you make sense of any of this, and all of this, within the span of just one family? What does this history mean?" (Reflecting upon it now, expecting him to be able to answer this question seems rather preposterous.) My family has many such stories—not easy to verify, nightmarish and mythic, and geographically dispersed. Obligingly, Gordon answered that, based on the personal account he'd heard me give during my talk, he considered how, while I began in Hong Kong, my family's dispersal and lack of a single origin challenges the long-held notion that, in telling Chinese history, any individual genealogy can be traced. Over the past century, such histories have spanned places ranging from Shanghai to Hong Kong, New York, Okinawa, the Malay Peninsula, and beyond. Perhaps the only thing that unites these places is that they are all ports. "Your family's

story," Gordon offered, "is really about 'no place.'" I've since sat with this idea of "no place." It's an upsetting concept, offering no direction for root-seeking, nothing to be nostalgic for, no territory to return to. It is a flippant specter; an unsettling, slippery place of no scent at all. From speaking to friends or students who might share a similar lineage, I know there are other stories about generations of the Chinese diaspora that involve locales such as Taiwan, the Philippines, and, in the Western hemisphere, Haiti or Mississippi. Not one of these routes draws the same line. Crucially, they describe peripheral oral histories that are associated with revolution, regime change, and, often, the Cold War.

*　　*　　*

This text, first written as a talk to be presented at Dia Art Foundation on the work of An-My Lê, pivots out of the poetic possibilities of "no place." Where I take this will extend beyond what Gordon offered me, but I am interested in reading "no place" as the singular presence of place as an elliptical concept. In geometry, Rosalyn Deutsche writes, "An ellipsis or ellipse is a curved figure with more than one focal point." However, the elliptical, she suggests, has a multivalent meaning. "Elliptical" also signifies "lack, incompletion, and the failure to achieve fullness and unity."[3] In performing a reading of An-My Lê's work through the lens of the elliptical, I am interested in

uncovering new ways to encounter her work; I am also interested in thinking through the ways in which she draws from a host of genres and visual vernaculars that describe place—in this case, Vietnam—as a dispersed fantasy that emerges in the space between images. From American landscape photography to travelogues, geologic or military surveys, and war photography, the landscape photograph typically performs a rather simple act: it situates the viewer in a place in order to transmit knowledge of a location. However, in Lê's 2005 publication *Small Wars*—an essayistic work containing forty-seven large-format black-and-white photographs—her images evince an estrangement from a narrative of place, whether situated in Vietnam (as in the first of the three series), in rural Virginia and North Carolina, or on a military base in Twentynine Palms, California. Articulating a politics of spatiality that challenges the American imagination of Vietnam, her works also produce a sense of unknowing and tension within a given landscape. They visualize Cold War history as littered with ellipses, inconveniences, and plot holes, but also assert a poetics of possibility in the intervals between each image. The photographs in *Viêt Nam*, the series that opens the book, do not easily situate Vietnam for the viewer; in the subsequent eponymous series, the works blend deception and rehearsal to construct landscape. Embedded in the logics and histories of landscape photography and performative reenactment, Lê's works operate pictorially

both *against and with* Vietnam as a televisual and photographic memory—what she calls "the Vietnam of the mind"—enacting a double gaze that intertwines America and Vietnam.[4] Here, "no place" might be understood as a peripatetic concept of place that forecloses the possibility of unity, resolution, or completion. Lê's work asserts a poetics that upends protocols of landscape photography and genre as it responds to fantasies of place.

The series *Việt Nam* and *Small Wars* might be considered twinned works that function as opposite sides of the same coin: place/fantasy. As a filmmaker, I am interested in the potential of rethinking these bodies of work as essay films, and repositioning Lê as a cinematic thinker working in a still-image medium, with a practice that touches broadly on depictions of Vietnam both on-screen and in print culture. In this context, the elliptical has yet another application in film: in looking at a series as a whole rather than dwelling on a single image, it is possible to reconstitute Lê's work as an elliptical montage that follows the sequence of the photographs. When I first presented this essay as a lecture-performance, the text enacted the cinematic device of the elliptical montage, calling upon the viewer's imagination to reconstruct the temporal duration embedded in the interludes between projected images, or to conceive of actions and events that might not be immediately apparent within the frames but in fact connect images in the sequence. Between the images, in other

words, lie others that rest invisibly in the viewer's consciousness. Projected at a cinematic scale during my live reading, An-My Lê's work may have been encountered as luminous shadows against a surface. My text, which acted as a kind of voice-over, moved through and reassembled the logics belying these images, their arrangements, and the interstices between them, in an attempt to create what Pavle Levi has called "cinema by other means."[5] At times, images and text aligned perfectly, but not always. Lê's works—presented in the lecture-performance as a rhythmic dialogue between text and a suite of images—articulate the imagistic ruptures of place underwritten by the circulation of images. What is visible in pictures powerfully grafts geopolitics, geography, and the history of the Cold War onto landscape; what remains invisible or off camera is vivified through text. These gaps and lapses reveal critical histories and discussions within and beyond Vietnam, surfaced as a distant imaginary "to expose the political unconscious of the global Cold War's visual regimes."[6] Rather than simply shatter such regimes of seeing or the Western fantasy of Vietnam, Lê's work iterates upon these fantasmatic constructions. In its published form, this essay projects a cinema through text in a continual encounter with place, page after page—with some digressions along the way. In this way, I aim to reorient the reader's perception and attempt to see Vietnam by attending to the formal kinship with cinema in Lê's works.

* * *

Soon after I moved back to New York, I had the Hong Kong artist Simon Leung over for dinner. He told me one of his memories of immigrating to the US from Hong Kong: while watching TV news reportage about the Vietnam War as a child, it occurred to him—at the very moment of this encounter with broadcast television—that he was on the other side of the world. The films that make up Leung's "Vietnam Trilogy"—*Warren Piece (In the 70s)* (1993), *Squatting Project/Berlin* (1994), and *Surf Vietnam* (1998)—were made more than twenty years after the end of the war, but each grappled with this unique and mediated site of encounter and revelation. Telescoping the 1967 documentary film *Loin du Vietnam*—which includes segments directed by seven filmmakers of the French New Wave, including Jean-Luc Godard and Agnès Varda—Leung asked, "How far is far from Vietnam?" The immediacy of broadcast television might create an illusion of proximity, but in that moment of seeing how the war was narrated and visualized through broadcast news, Leung realized that Vietnam—or Asia, really—was not near at all, but altogether elsewhere.

* * *

"Over the years," Lê observes, "disconnected from the place and with only a handful of family pictures avail-

able, I had come to construct my own notions of a Vietnam drawn mostly from memories, but also from photojournalism and Hollywood films."[7] Suspended in a slice of contemporary Vietnam, the timeless agrarian landscape presents itself as a paradox in the *Viêt Nam* series. Composed of photographs taken in the 1990s that include pastoral landscapes, exterior shots of street life, and some contemplative interior shots, the series constructs a fantasy that speaks, on one level, to a child's or adolescent's memory of Vietnam, and on the other to a collective regression from the rapidly industrializing Vietnam of the 1990s, when the country's textile and electronics sectors boomed. If reframed as a film, *Viêt Nam* and *Small Wars* would be the successive chapters in an imagistic narrative that begins with a wide shot of a pastoral Vietnam. Palm trees and cows, reduced to small figures, speckle the horizon of a tropical plain. A riverbed cuts across, and mountainous rock formations anchor the composition. The first series, *Viêt Nam*, spelled with a circumflex over the "e" and divided into two words (notably, a Viet spelling rather than an English one), opens on a close-up of a young girl wearing a blouse, necklace, and hat—accessories that are anachronistic in the context of most other shots in the work, whether long or medium ones. The child is, in fact, a recurring figure in Lê's *Viêt Nam* series. Through the close-up, the immediate sense of proximity to the child feels personal—it is an establishing shot that announces the young girl as a protagonist from the outset.

Lê left Vietnam when she was fifteen, in 1975, the last year of the war. As she reflected in a conversation at Yale University with photographer Peter van Agtmael, "It was devastating what Americans did to Vietnam, but they saved my life, and I was airlifted."[8] Lê also mentions the ambivalence she had to deal with in the aftermath of war and exile, as she found herself caught between a critique of the American war machine and her own experience as a refugee of war. While she spares the viewer the lurid details of violence in these photographs, the specter of that violence hovers in the atmosphere. Her photographs assume, and also rely upon, the viewer's knowledge of other iconic images of the war, and the imaginaries upon which the series elaborates pictorially. As Lê describes in an interview with Hilton Als in the book *Small Wars*: "In 1994 when I returned for the first time, I realized that I was not particularly interested in reexamining contemporary Vietnam. Instead of seeking the real, I began making photographs that use the real to ground the imaginary."[9] The fantasy of an "elsewhere" also becomes a fantasy of the "here," as the two begin to merge. It is in this sense that Lê's photographic practice starts to reveal itself as akin to cinema. If, in Susan Sontag's estimation, "the painter constructs" while the "photographer discloses,"[9] Lê's images propose that "photography is always a construction"[11]—just like cinema.

The *Viêt Nam* series vivifies the past and memory in an intimate manner, seeking reconciliation

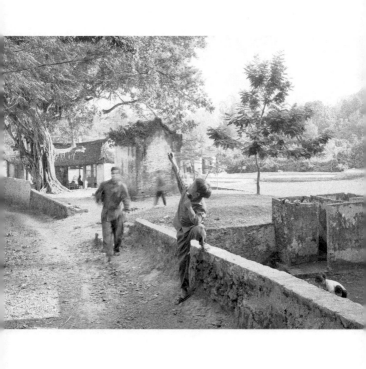

This page: An-My Lê, *Untitled,
Mekong Delta*, from the *Viêt Nam*
series, 1994.

Previous page: An-My Lê, *Untitled,
Tien Phuong*, from the *Viêt Nam*
series, 1995.

with place and childhood by using captured images of everyday life and landscape that weave between the power of truth, memory, and fantasy. In so doing, Lê offers a kind of visual repair for the absence of family photographs—innocent scenes of soccer in a schoolyard, kites in the air, revelers at an eclipse. Through the absent presence of these scenes, we begin to see Lê grapple with photography's relationship to the invisible. As Thy Phu remarks, "First, the war in Vietnam played a special role in visual history, and, second, an influential thread of studies on photography developed in response to images from this war. Although I studied these lessons, over the years my doubts deepened with the hazy recollection of half-forgotten scenes, though whether witnessed firsthand or described to me I could no longer tell."[12] In the face of the massive proliferation and circulation of images of the Vietnam War, the catastrophic memory of lived and mediated scenes begins to blur, yet Lê's work insists that the lost genre of the family portrait might still be resurrected as memory.

The exile is a detached figure. Not so much in the negative, uncaring sense of the word, but in the sense of being detached or dissociated from both one's place of origin and one's new place. How might we notice "no place" in the no-man's-land of battlefields, or in the blur of an outdated or partial memory of exile? Lê's photographic tableaux inhabit a double consciousness, an exilic gaze. She offers

no easy way out of these histories, but completes the elision of these bilateral regimes of seeing as embedded formal tensions. "Most people are principally aware of one culture, one setting, one home," Edward Said argues—but "exiles are aware of at least two, and this plurality of vision gives rise to an awareness of simultaneous dimensions, an awareness that—to borrow a phrase from music—is *contrapuntal*."[13] Drawing across time and space, the specificities of place dissolve. Which landscape is Vietnam? Which is Virginia? This double gaze in Lê's works produces what she has described as a "complicated picture." The more you see these places, the less you know. "The . . . camera has provided me with multiple shields from the painful memory of war," she remarks, "while allowing me to come as close as possible to try to understand it."[14] The image is a plane of reckoning and dissociation that allows the artist to gaze at the sublimity of history in its total horror and awe. This ambivalence is at play in each photograph. To borrow the words of Lauren Berlant, "ambivalence" here means not so much "the atmosphere of negativity it currently brings with it" but a "genuinely conflicted experience that allows us to face up to such complex scenes."[15] One can turn this affect of ambivalence—not a passive affect in Lê's work, but an extremely present and active one— over and over in these pictures.

* * *

I remember developing an intense attachment to my parents' CRT television in the 1990s; I spent many hours in front of it, unsupervised. So visceral were these experiences, I still vividly remember running my fingers across the monitor and feeling the screen zap with static. My initiation into American culture, before I immigrated to the US from Hong Kong in 1996, was accomplished through the screen, via *The X-Files* and John McTiernan's *Die Hard with a Vengeance*. Visiting my aunt and uncle in Manila, I relished their access to MTV, secured through the exclusive American cable syndicate channels in the Philippines. My parents were largely absent from my childhood, and the TV took on a constant, avuncular presence. In 1997, at the age of nine, I watched the handover of Hong Kong from a makeshift fort in the living room. My parents were out on the town toasting the historic moment with their friends, having left me and my friend with the nanny. I was told the handover was the reason my family had left, one of many stories explaining our flight from Shanghai. These fragments of family history, as well as this televisual memory, vexed me about the world of adults. In July 1997, the streets of Hong Kong looked the same as they had the month prior, and the transnational ceremony handing over sovereignty seemed so underwhelming in the rain. I remember waking up to being tucked into bed.

Amid the fast-moving events of twentieth-century war, Lê's camera and its slow shutter speed run counter to the immediacy of action. Time is the technology through which Lê manipulates the image. By working with a large-format camera and using long exposures, she achieves another temporality, one that opens onto a phantasmic, dreamlike plane. Like the hypnagogic gaze of the sleeper blinking slowly into slumber, much of Lê's landscape imagery depicts quick movements captured as indistinct blurs. These moments of blur release the image from the intense precision and clarity of the photographic register. In her pastoral scenes of a Vietnam haunted by the catastrophic, the hypnagogic gaze might be fundamentally aligned with the figure of the child. A trope in anti-war photography, the child, history's most sympathetic victim, is often the figure who pleads for empathy. We may not recall the names of the photographers or the first time we encountered these iconic images of the Vietnam War, but the widely circulated photographs of children caught in the midst of violence are etched into our memories. And while we might understand the existence of the child as a vehicle for empathy, especially in images of war and turmoil from far-flung locales, the child is also, importantly, to be abandoned by the viewer, who as a voyeur experiences violence as a mediated event taking place at a safe distance, rather than a direct threat.

148

Lê's works push past the framework of the child as an image and move beyond pleas for empathy, beyond the child as a redemptive or an overly sentimental figure. The child's gaze, to borrow the words of Jean Ma, demonstrates a kind of "alert curiosity . . . embodying not a receptive stance that is disconnected, closed in upon itself, and mired in oblivion, but rather one characterized by wonder and receptive openness to the world."[16] Lê invites us to read the child in these photographs not as a distanced subject, but as a figure reenacting the myth of place through the phantasmagoria of memory. The child personifies a dream of place through the prism of the past—the myth of place resting somewhere between truth and distortion. "When you live in exile," as Lê remarks, "you start intensifying certain things and you forget other things. It lives in your head, in dreams."[17]

In Cantonese culture, *bei guai zak* is the term for sleep paralysis, believed to occur when a ghost sits on your chest—similar to the Vietnamese term *ma đè*, meaning to be held down by a somnolent spirit. In the West, the term for this phenomenon is "the night hag," a reference to the malevolent agent that sits atop the sleeper's chest or at the foot of the bed; the term "nightmare" was traditionally associated with this superstitious mythology before taking on its current meaning ("a bad dream").[18] The disquieting landscapes in Lê's work invoke the relationship between ghosts and history. Apparitional figures echo the motifs of smoke and mist that recur throughout

the photographs in *Viêt Nam*, and in subsequent series like *Small Wars*. "Ghosts are, in Vietnamese conception, the categorical opposite of ancestors, and as such they become strangers to the local community when this community enacts a ritual unity with its ancestral memory."[19] Ghosts are, in this view, akin to exilic figures. In the political cusps that consolidate new regimes of power, the exile becomes a figure that strikes out of time. The exile has *run out of time* but is also *out of sync*, uprooted and ejected from their ancestral lands. Stuck in time, "the nightmares of history," as Ma observes, "replay on an endless loop."[20] An exilic figure embodies displaced memory, something irretrievable and unrecoverable. In Lê's photographs, a blurred face invokes a horror trope: disfiguring, the blur also acts as a veil upon the visage constructed by the slow shutter. A figure eluding the moment of photographic capture, an apparition that cannot be put to rest.

* * *

In *Small Wars*, Lê illuminates the relationship between reenactments, war training, and simulations, exploring their intrinsic ties to memory and the history of war. So much in the theater of military operations is already a rehearsal for the event of battle. The Vietnam War reenactments that Lê both participates in and photographs in *Small Wars* perform a kind of doubling of the rehearsal already embedded in the

temporality of the battlefield—a repetitive loop of motion caught between anticipation and action. This deployment of reenactment as construction also takes on a highly filmic quality. As Bill Nichols observes on the use of reenactment in documentary film:

> Reenactments enhance or amplify affective engagement. Reenactments contribute to a vivification of that for which they stand. They make what it feels like to occupy a certain situation, to perform a certain action, to adopt a particular perspective visible and more vivid. Vivification is neither evidence nor explanation. . . . [Reenactments] effect a fold in time. Reenactments vivify the sense of the lived experience, the *vécu*, of others. They take past time and make it present. They take present time and fold it over onto what has already come to pass.[21]

Reenactment possesses the bewitching power to resurrect memory, to undo time and reanimate a person from the historical past. Lê even takes on the role of a Viet Cong "sniper girl"—an anonymous historical figure—adding authenticity to the event. In the photograph titled *Sniper I*, she appears in her own image, playing a female Viet Cong crouched and hidden behind tall grass on the knoll in the foreground of the picture. She is raising a rifle to her shoulder, taking aim at American soldiers in the

background. Lê relays that the reenactors taking part in the construction of these scenes "would often concoct elaborate scenarios around my character."[22] But it's not just her role as an incarnate Viet Cong that makes the scene vivid; Lê's act of photographing war reenactments ensures the verisimilitude of their performances by capturing them as images. She returns them to the realm in which they were originally experienced or referenced by the reenactors. Photographing these events formally connects them to how Vietnam as a media memory has been received and performed.

<p style="text-align:center">*　*　*</p>

I grew up attending a Chinese Baptist church in North Point, a historically leftist neighborhood in Hong Kong where many Shanghainese and Fujianese émigrés and refugees settled in the wake of the Cultural Revolution. North Point was also the focal point of the 1967 leftist riots, and the neighborhood where my father's family settled when they arrived in Hong Kong. I avoided Sunday school to join the service with the adults. Service began at eight o'clock and lasted until noon, four hours of songs and sermons—a format so grueling and lengthy that, as I got older and increasingly distanced from religious doctrine, I began to disengage. Tuning out was an active experience. It took tremendous inner attention and effort to dissociate from the space. In the

afterlife of this performance as text, in its discussion of sleep and dreams, are any of my readers bored yet, or already asleep? If so, I don't mind at all. I ask not as an accusation against inattention; rather, I welcome it as a dare. The filmmaker Abbas Kiarostami once said, "I prefer films that put their audience to sleep in the theater. I think those films are kind enough to allow you a nice nap. . . . Some films have made me doze off in the theater, but the same films have made me stay up at night, wake up thinking about them in the morning, and keep on thinking about them for weeks. Those are the kind of films I like."[23] If a book can put one to sleep in the same way, I might relish the opportunity to help my reader doze off.

After church, we would spend several hours at Laser People, a video and laser disc store in Happy Valley. At night, we would put movies up on the projector. My parents never bothered to check film ratings. My mom would always fall asleep, but could somehow recount the movie better than we could the next day. These moments of gathering around to watch films together opened a portal through which I peered into the world of adults, of violence and sex onscreen. Memories are folded into so much forgetting.

*　　*　　*

The "Vietnam of the mind" is a fictive place. It is a "no place." Not a *non*-place, in the words of Marc

Augé, who attaches this term to sites such as airports, shopping malls, or hotel rooms—transient locations where human beings remain anonymous.[24] Rather, "no place" is a vision of locales whose specificities are blurred by invasion, violence, and hostility—contested territories, seized ports or battlefields, contact zones or port cities. When confronted with An-My Lê's landscape photographs, I am interested in using Gordon Chang's conversational proposition of "no place" as a way to embrace a poetic, elliptical absence of return, resolution, or completion. These are places that have gone through such a violent transfiguration that they are rendered neither neutral nor anonymized, but rather take on a slippery quality: the "no place" cannot be known—it remains an enigma and lives on as specter.

The "Vietnam of the mind" appears so often in images that such images purport to make the place known, though they only support and propagate its fictions. These are images that circulate not just as still photographs, but also as image worlds embedded in popular films, like Francis Ford Coppola's *Apocalypse Now* (1979), Stanley Kubrick's *Full Metal Jacket* (1987), Brian De Palma's *Casualties of War* (1989), Oliver Stone's *Platoon* (1986), and Pierre Schoendorffer's *The Anderson Platoon* (1966), which An-My Lê cites in *Small Wars*.[25] *The Anderson Platoon*, like much news reportage of its time, is shot on handheld cameras, shaky and moving like a body or pacing alongside the infantry line in combat or

moments of waiting. In contrast, large Hollywood productions like *Apocalypse Now*, which more closely resemble military operations in scale and budget, restage Vietnam in the Philippines. Upon that film's premiere at the Cannes Film Festival in 1979, Francis Ford Coppola said, "My film is not a movie. My film is not about Vietnam. It is Vietnam. It's what it was really like. It was crazy. And the way we made it was very much like the Americans were in Vietnam. We were in the jungle. There were too many of us. We had access to too much money. Too much equipment. And little by little, we went insane."[26] Filmed in the Philippines, Northern California, Thailand, and elsewhere, *Apocalypse Now* and other Hollywood productions are emulations of that "Vietnam of the mind"—not Vietnam at all, but a symbolic Asiatic terrain whose visual proxies are interchangeable.

In contrast, Vinh Nguyen argues that "one of the most important cultural documents of the war in Vietnam emerged not from the usual 'sites' of production—the United States, the Socialist Republic of Vietnam, the now defunct Republic of Vietnam (South Vietnam), or the Vietnamese diaspora—but from the Hong Kong film industry of the 1980s,"[27] citing the example of Ann Hui's 1982 film, *Boat People*, which was part of a trilogy. The film tells the story of a Japanese photojournalist who travels to the country to document life under socialist rule; outside of the state-controlled tours he takes part in,

he meets a group of children he becomes invested in. As he learns about their lives, they rob graves and scavenge through garbage riddled with unexploded ordnance to survive. They reveal to him a side of the country that the state did not want him to see. Based on the collected accounts of over one hundred Vietnamese refugees who arrived in Hong Kong in 1978, and enlisting Hong Kong Chinese actors, *Boat People* depicts the tragedy and vicissitudes of war.

The production, circulation, and reception of *Boat People* evinces several ideological paradoxes. One of the executive producers on the film was the director of Xinhua News Agency, China's state news. In a meeting with Hui, he divulged that as a backer of the film, he could attest to it having been intended as "anti-Vietnam propaganda." And indeed, upon the film's release, the Vietnamese government was offended by its portrayal of the country. Despite it being originally funded by the Chinese state as agitprop, however, European critics opposed the film's one-sided, negative depiction of the war upon its premiere at Cannes. Questioning what they read as Hui's right-wing stance, they asked her whether she felt that such a damning critique of Vietnam "[took] away from the ferocity" and the "authenticity" of the film, making it "somewhat suspect"?[28] The director said her experience at Cannes was "eye-opening," but she declared she had not intended to make a political film. To complete the irony, *Boat People* was eventually banned in China when Hong Kong

audiences read the film as a political allegory for their city's own relationship to the Cold War. Beyond Hollywood films, there are multiple visual regimes of the Cold War that together construct the "Vietnam of the mind." These reveal a lattice of tensions that extends across a North-South divide, transcending a simplistic East-West conflict.

Vietnam has been a contested territory in the consolidation of empires for centuries. Since 420 CE, Vietnam has been alternately colonized and invaded by China, France, Japan, the British Empire, and the United States. To illustrate the capacity of nationalistic ideology to rewrite memory, Benedict Anderson evokes a historical anecdote that belies the country's sovereignty. As Anderson observes, the name "Vietnam" was "scornfully invented by a nineteenth-century Manchu dynasty" to refer to a territory "conquered by the Han seventeen centuries earlier and reputed to cover today's Chinese provinces of Kwangtung and Kwangsi, as well as the Red River valley."[29] Despite the Vietnamese court privately inventing another name for its own kingdom, the ambivalently adopted name, Anderson continues, "reminds us of [Ernest] Renan's dictum that nations must have 'oublié bien des choses' [forgotten many things]."[30] Nationalism relies on amnesia—a considerable amount of mass forgetting—to gain power. Places, like dates, become multivalent. Thy Phu chronicles one historic date that describes the splintering of memory:

April 30 is a day of liberation, according to the Socialist Republic of Vietnam. For the overseas Vietnamese, however, this is Black April, the anniversary of the day in 1975 when the Republic of Vietnam disappeared. . . . The commemorations are rites of remembrance and a form of reenactment.[31]

A double gaze might also describe the splintering of historical dates into two meanings—and how the vicissitudes of war create a divided national consciousness that lives on in the diaspora. A date cleaves the paradigm that rules memory and history. Acted upon by multivectored hegemonies and millennia of conflicted historical memory, the "Vietnam of the mind" is an ever-slippery "no place."

* * *

Large plumes of smoke occupy many of An-My Lê's images. In *Viêt Nam* and *Small Wars*, as well as later works such as *Trap Rock* (2006), mist, fog, smoke, and clouds of dust emerge within vast landscapes. Apparitional in quality, their shapes have multivalent meanings: as cinematic trope, as military weapon, as natural element and sublime force. In cinema, haze, fog, smoke, and other in-air diffusions are used to create a dispersed, ethereal light or add dramatic, evocative depth to space. In films such as King Hu's *A Touch of Zen* (1971) or *Dragon Inn* (1967), rather

than wait for the desired weather conditions, iconic landscapes were artificially produced. Hu burned reeds that were tied together in the shape of a barrel—a method that allowed air to move through the hollow core of the makeshift device and wind to push the smoke that billowed forth. Attempting to re-create the aesthetics of ink-scroll paintings, King Hu saw smoke as a way to produce negative space in cinema by juxtaposing mountains and mist on film.

But in the theater of war, obscurants have many tactical applications: the phrase "fog of war" describes the uncertainty and lack of situational awareness in combat in both strategic and psychological terms, and smoke can be used to conceal or to mark—to provide a defensive screen to hide operations or to be launched on the enemy as a tactic of confusion. Military uses of smoke range from the breathable and vaporous to the asphyxiating and incendiary, depending on the chemical agent. If Lê vivifies memory and "no place" through the photographic medium, her fondness for these apparitional smoke forms plays poetically with photography's relationship to disclosure and concealment. The diaphanous shapes add a dreamlike quality to their settings, but their multivalence only amplifies the concurrent menace and beauty that rule the landscape photograph.

"All wars are fought twice," Viet Thanh Nguyen has argued. "The first time on the battlefield, the second time in memory."[32] While Nguyen

describes himself as a scholar of memory, we might similarly think of An-My Lê's work as a termite practice[33] on a locus of memory, whether that recollection is mediated or lived. Not simply oppositional, Lê proposes a range of formal tactics, complexities, and dualities in visual forms that compound the sublime. These photographic landscapes embrace the "no place" that lies between awe and horror. In Vietnam, the war we refer to here as "the Vietnam War" is called "the American War."

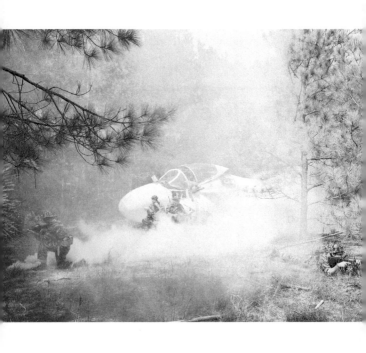

This page: An-My Lê, *Rescue*, from
the *Small Wars* series, 1999–2002.

Previous page: An-My Lê, *Sniper I*,
from the *Small Wars* series,
1999–2002.

Notes

1. See Gordon H. Chang, *Ghosts of Gold Mountain: The Epic Story of the Chinese Who Built the Transcontinental Railroad* (Boston: Houghton Mifflin Harcourt, 2019).

2. See Lauren Berlant, *On the Inconvenience of Other People* (Durham, NC: Duke University Press, 2023).

3. Rosalyn Deutsche, *Not-Forgetting: Contemporary Art and the Interrogation of Mastery* (Chicago: University of Chicago Press, 2022), 100.

4. An-My Lê, *Small Wars* (New York: Aperture, 2005), 124.

5. See Pavle Levi, *Cinema by Other Means* (Oxford, UK: Oxford University Press, 2012).

6. I borrow this phrase from *Cold War Camera*, ed. Thy Phu, Andrea Noble, and Erina Duganne (Durham, NC: Duke University Press, 2023), 11.

7. An-My Lê and Peter van Agtmael, "An-My Lê and Peter van Agtmael," moderated by Judy Ditner, Yale University Art Gallery, November 2, 2017, YouTube video, 1:23:50, youtu.be/VDTfiJIXmXM.

8. Lê and Van Agtmael, "An-My Lê and Peter Van Agtmael."

9. Lê, *Small Wars*, 119.

10. Susan Sontag, *On Photography* (New York: Picador, 1990), 92.

11. Lê and Van Agtmael, "An-My Lê and Peter van Agtmael."

12. Thy Phu, *Warring Visions: Photography and Vietnam* (Durham, NC: Duke University Press, 2022), 9.

13. Edward W. Said, "Reflections on Exile," in *Reflections on Exile and Other Essays* (Cambridge, MA: Harvard University Press, 2000), 186.

14. An-My Lê, quoted in HG Masters, "An-My Lê: Theater of Observation," *ArtAsiaPacific*, no. 60 (September–October 2008): 170–79.

15. Berlant, *On the Inconvenience of Other People*, 8.

16. Jean Ma, *At the Edges of Sleep: Moving Images and Somnolent Spectators* (Oakland: University of California Press, 2022), 150.

17. Brainard Carey, "An-My Lê," July 6, 2021, in *Praxis Interview Magazine*, WYBCx—Yale Radio, podcast, 19:44, museumofnonvisibleart.com/interviews/an-my-le/.

18. Thomas A. Green, *Folklore: An Encyclopedia of Beliefs, Customs, Tales, Music, and Art* (Santa Barbara, CA: ABC-Clio, 1998), 588–89.

19. Heonik Kwon, *Ghosts of War in Vietnam* (Cambridge, UK: Cambridge University Press, 2008), 11.

20. Ma, *At the Edges of Sleep*, 92.

21. Bill Nichols, "Documentary Reenactment and the Fantasmatic Subject," *Critical Inquiry* 53, no. 1 (Autumn 2008): 88.

22. Lê, *Small Wars*, 121.

23. Abbas Kiarostami, "Abbas Kiarostami Discusses His Directorial Style," FirouzanFilms, uploaded November 26, 2008, YouTube video, 6:44, youtu.be/HxukX96bqAU.

24. See Marc Augé, *Non-Places: Introduction to an Anthropology of Supermodernity* (London: Verso, 2008).

25. Lê, *Small Wars*, 124.

26. From the opening scene of *Hearts of Darkness: A Filmmaker's Apocalypse*, directed by Eleanor Coppola, Fax Bahr, and George Hickenlooper (1991).

27. Vinh Nguyen, "Ann Hui's *Boat People*: Documenting Vietnamese Refugees in Hong Kong," in *Looking Back on the Vietnam War: Twenty-First Century Perspectives*, ed. Brenda M. Boyle and Jeehyun Lim (New Brunswick, NJ: Rutgers University Press, 2016), 94.

28. Excerpts from a conversation between Ann Hui and Stanley Kwan: "Ann Hui and Stanley Kwan on BOAT PEOPLE," August 2021, Criterion Channel, 27:06, criterionchannel.com/videos/ann-hui-and-stanley-kwan.

29. Benedict Anderson, *Imagined Communities: Reflections on the Origin and Spread of Nationalism* (London: Verso, 2016), 157.

30. Anderson, 158.

31. Thy Phu, *Warring Visions*, 121.

32. Viet Thanh Nguyen, "Just Memory: War and the Ethics of Remembrance," *American Literary History* 25, no. 1 (2013): 144–63.

33. Manny Farber, "White Elephant Art vs. Termite Art," *Film Culture*, no. 27 (Winter 1962–63): 9–13.

A Blurred Conceit

Over the Fourth of July weekend in 2023, Ed Halter and I made a trip to a Stop & Shop in Rhode Island to buy sparklers and smoke bombs, dog-friendly pyrotechnics for the occasion. We were at my in-laws' for the holiday weekend with Thomas Beard and my husband, Andrew. As we stood out by the water, attempting to light a smoke bomb in the wet grass, I asked Ed to expand on Jonas Mekas's notion of the politics of small countries—a topic that had come up a few months prior when he and I were running a series of workshops and events together. Small plumes of yellow and red smoke spilled forth, backdropped by the water.

The workshops and events were for the Washington Project for the Arts, and had been presented as part of their program titled "Apparitional Experiments." Included were in-person discussions with my friends and collaborators Jonathan Yu, a calligraphy artist, and Emily Verla Bovino, an artist and art historian, as well as an online event with the anonymous collective the Centre for Land Affairs, based in Hong Kong. The members of this group participated remotely via Zoom, but off camera, their voices muted to protect their identities.

I hadn't seen Jonathan and Emily in person for several years, so there was a lot to catch up on. I'd sometimes stayed up into the late hours on a work night just to finish a conversation with one or both of them over text; still, there is only so much you can communicate over Signal. In person,

we could more easily share stories about Hong Kong since the 2019 movement—stories from inside the city and others concerning people we knew who had since relocated. At last, we were really able to talk—though the irony of these long-overdue conversations taking place at a Cheesecake Factory near K Street in Washington, DC, wasn't lost on us.[1]

As he listened to our conversation, Ed remarked that it had finally dawned on him—Hong Kong's distinctive historical position, that is—and he mentioned Mekas's theory of the politics of small countries while discussing Lithuania, the filmmaker's homeland. Months later, in Rhode Island, Ed would explain how Mekas made a distinction between the particular politics of "small countries" and "big countries." He expanded on this in his essay for *Jonas Mekas: The Camera Was Always Running*:

> Coming from Lithuania, a small country besieged by both Germany and the Soviet Union during World War II, Mekas expressed resistance to overarching ideologies and imperial ambitions; art provided access to a truth that neither required, nor desired, dogma and power. "You don't have to be a Communist to be an anti-capitalist," he opined in 1960. "It's enough to be a poet." A few years earlier, he had recorded some stray thoughts on the nature of small countries versus big countries. "I am a regionalist,"

he began, "No abstract internationalism for me."[2]

Mekas posited that, in "small countries," politics have their own unique configuration and logic, which are necessarily different from those of "big countries." Navigating these shifts in scale is an incongruous task that brings odd bedfellows into relation. Mekas, Ed explained, attempted to reconstruct a Lithuanian rural imaginary in the United States, assembling it "out of the trees in Central Park, out of the romps upstate with his American friends."[3] Through his diary films, Mekas found a way of returning to the original place.

*　*　*

"Frequency illusion" is the name of a common phenomenon: after learning of something for the first time, you begin to notice that thing over and over again. Whether an idea, an object, or a word, the thing begins to appear so often as to trick the mind into believing that its occurrence should be read as a sign—or even as kismet. Also known as the Baader-Meinhof effect, this experience does not mean the thing itself has become ubiquitous or is in fact a harbinger; it is merely an example of cognitive bias. Your mind is unconsciously searching for something, creating the illusion of a pattern. While researching and writing, I often experience frequency

illusion associated with Hong Kong, my birthplace: I seem to find its name in unexpected places on the page. Perhaps Mekas, too, saw Lithuania everywhere he looked.

While reading Michael Warner's *Publics and Counterpublics*, for instance, I was surprised to find that the author turns to Hong Kong to make a point about the complex definition of a public; he invokes Hong Kong cinema to discuss the hyperplasticity of publics that extend beyond a single defined locality.[4] For Warner, this expanded notion of a public, catalyzed by an "engine of translatability," enables a work and form to "[put] down new roots wherever it goes."[5] This is where my motif ends, though: Hong Kong, figured through its cinema, does not make another appearance in his study.

Hong Kong reared its head again in the book *Design Studies: A Reader*, a collection of essays edited by Hazel Clark and David Brody.[6] The city appears in a chapter about early modern design, where it is cast as an originary site for the birth of serial production, a critical port for colonial trade. In another chapter, the graphic makeover of Hong Kong and the Shanghai Banking Corporation (since rebranded as HSBC) is used as an example of the codifying of global corporate identity in the 1980s. The book concisely describes the city's imprint on the global industrial economy, as well as Hong Kong's role in the formation of the multinational corporate imaginary.

Perhaps most curiously, I encountered Hong Kong in James Baldwin's 1964 essay "Nothing Personal," which originally appeared in his collaborative publication with photographer Richard Avedon of the same name. "Pretend, for example," Baldwin writes, "that you were born in Chicago and have never had the remotest desire to visit Hong Kong, which is only a name on a map for you; pretend that some convulsion, sometimes called accident, throws you into connection with a man or a woman who lives in Hong Kong; and that you fall in love."[7] This mention of Hong Kong, a place pointed at randomly on a map to signal the faraway, feels so personally specific to me, but also demonstrates how a distant place can become proximate, even intimate in feeling, through encounter or relation. I sat with Baldwin's essay for several years, rereading it frequently to try to make sense of it. Emmy Catedral, a friend, texted me a picture over WhatsApp of Baldwin wearing a Chinese silk blouse. A clue, perhaps? We speculated that he may have had a faraway lover, that Hong Kong to him was a potent elsewhere.[8]

I later discovered that Baldwin spent stints in Turkey between 1961 and 1971—a prolonged sojourn in what became, for him, an exilic haven where he wrote some of "his most important, and arguably most American, works," as Magdalena J. Zaborowska remarks, including *Another Country* and *The Fire Next Time*.[9] It was during these years,

too, that Baldwin published "Nothing Personal" with Avedon—reflecting, as he often did, at a distance. "You will," he writes, "[. . .] as long as space and time divide you from anyone you love, discover a great deal about shipping routes, airlines, earthquake, famine, disease, and war. And you will always know what time it is in Hong Kong, for you love someone who lives there. And love will simply have no choice but to go into battle with space and time and, furthermore, to win."[10] When he makes this connection between Chicago and Hong Kong, perhaps the former serves as a proxy for Harlem, his original home. Hong Kong then operates as a proxy for Istanbul: another East-West nexus that stands on the margins of empires and continents, apart from the United States, both cities made and unmade by global historical shifts. Whether or not Baldwin had a lover in Turkey, that country played an important role in his life as a site of refuge, offering him the critical distance he needed to contribute to the notable collection of American letters in exile. In Baldwin's words, Turkey "saved my life . . . [by making me] able and willing to accept [my] own vision of the world, no matter how radically this vision departs from that of others."[11]

Hong Kong, a city of asylum, is also a major, if enigmatic, character in Laura Poitras's *Citizenfour* (2014), which documents the case of Edward Snowden, whom she films in the Mira, a hotel in Kowloon. Snowden first came to mind while I was

writing the essay "Elliptical Returns" (p. 81).[12] I was struck by the question he asked as he prepared to meet the press for the first time since his location had been revealed: "Is there precedent for this, where Hong Kong would extradite someone for political speech?" He couldn't have known how eerie this question would sound; and to me, looking back, it felt oddly prescient in the immediate lead-up to the Umbrella Movement of that same year, and to the anti-government protests that would follow in 2019, which were sparked by the extradition bill.

My editor for that essay, B. Ruby Rich, commented on the segue I had made from Baldwin to Snowden in an early draft: the two seemed like odd bedfellows, she remarked, recommending I cut mention of the latter entirely, or simply reference him in a footnote.[13] Indeed, they did make odd bedfellows on the page, but I wondered how much this particular strangeness epitomizes Hong Kong's history, which has often been layered with fraught paradoxes. I opted for the footnote. Months later, after the article had come out, my friend the scholar Joan Kee reminded me that Snowden's location in Hong Kong had been discovered thanks to the excellent investigative skills of the reporters at the now-defunct *Apple Daily* and the sex workers they enlisted to identify the backdrops pictured in Snowden's television interviews. The Mira's slick furnishings, characteristic of the midscale business hotel, were recognized immediately, and Snowden's

hideout was successfully identified, kicking off the events that Poitras's film so perilously and critically captured.

And there was also Fadi A. Bardawil, who, while attending to other geographies, indirectly deals with the heart of Hong Kong cultural theory. Theorizing toward a revolutionary framework that would decenter the US and multipolar hegemonies, Bardawil outlines the critical strategies needed to undo the binaries that revolutionary discourse often finds itself yoked to:

> Critical strategies that rely exclusively on speaking back to the West through marshaling a set of binaries—West/non-West; homogenization/difference; universal/particular; secular/nonsecular; westernized elite/nonwesternized masses; liberal Muslim/nonliberal Muslim—that retain the West at the heart of their deepest attachments have become increasingly problematic in the wake of the Arab revolutions.[14]

A conceptual situation of this sort is not unique to the Arab world. Bardawil channels the work of Rey Chow to complete the critique, anticipating the characterization of his thinking as Arab exceptionalism. He cites the ways in which Chow's work "interrogate[s] the self-referentiality of the knowledge produced by area studies that, by focus-

ing on 'targeting or getting the other,' ends up consolidating 'the omnipotence and omnipresence of the sovereign . . .' that is the United States."[15] It was in seeing the connection Bardawil made between Arab studies and Hong Kong studies that I felt a kind of permission to draw out the relationship between those two fields for myself (I often find that Hong Kong is not included in global postcolonial revolutionary discourse), and cited Bardawil in the essay "Elliptical Returns" (p. 115). Discussing the "deadlock" of revolution in a postcolony—and the many binaries that solidify this stuckness—Bardawil spells out the trap of getting caught between "authoritarian nationalists" and "imperial democrats."[16] Postcolonial revolutionary discourse often attracts such odd bedfellows, leading to the inevitable dead end of political disenchantment.

Encountering Hong Kong in these passages—in unexpected, odd, and sometimes revelatory contexts—and piecing them together here, it seems as if the city could be textually reconstructed on the page. By drawing connections where I had not before, it is as if I could encounter the original place anew.

*　　*　　*

On a Sunday in early 2023, after several consecutive weeks of juggling my day job and my studio practice, I finally relented and allowed myself a break.

Andrew and I had my parents over for an early dinner. I put on King Hu's *Dragon Inn* (1967) for them to watch, recalling an evening over a decade ago when I made them watch Hou Hsiao-hsien's *City of Sadness* (1989). My dad was grumpy about having had to sit through a nearly three-hour-long film. "Nothing really happens," he complained. "Next time we'll pick the movie." Later he relented, saying: "This is what Shanghai was like." When the 2019 protests consumed Hong Kong, my parents lost many of their friends. Believing his generation had forsaken the youth now out on the streets, martyring themselves as front-liners in the protests, my dad got into heated arguments with former classmates and business acquaintances on Facebook. Many of them still do not speak to him. Despite my parents' initial resistance to *City of Sadness*, years later they would remark on how much the film's depiction of Taiwan's period of White Terror[17]—while inverting the ideological context—seemed to mirror the events in Hong Kong as the new era of the National Security Law set in.

That Sunday night, though, when the opening title credits of *Dragon Inn* appeared on the screen, that iconic Chinese chamber music soundtracking the sequence, it struck me that being there with my parents felt like returning to a familiar place. It was both through and alongside them that I first encountered Hong Kong cinema. My mother was always the cinephile of the family, though it

wasn't apparent to me as a child. One of eleven children—ten daughters and one son—she grew up in Sham Shui Po, a neighborhood in Kowloon that, at midcentury, was coastal. Later, land reclamation—a large and ongoing project to extend Hong Kong's landmass—would transform the area, bringing it inland. Sham Shui Po was also where the Japanese built a prisoner-of-war camp and settlement during the Pacific War. My mother was born in 1951, and grew up hearing adults tell stories about wartime famine and the restless ghosts who still wandered around in agony.[18] By the time she was a teen in the 1970s, the area had become a booming industrial neighborhood and an important center for the wholesale and manufacture of textiles.

My grandparents did not have time for any of their daughters, only for their one son, so they conscripted the girls to take care of one another in pairs. Several were sent to my great-aunt's house so she could help raise them. Other, worse things I will not name. When some of the daughters were old enough, they took on more of a parental role in the family than my grandparents ever had. My mother, the fourth eldest, assumed such a role. A precocious child, she was assigned to run errands for the family; she learned to navigate the bus system and lined up in queues to consult medical specialists for my grandmother, who had endured a postpartum hernia. Having become useful to my grandparents in other ways, too, my mother was pulled out of

school as a teen to work for my grandfather in his textile production line. There was one perk to being the family's errand runner and child worker: she got to go with her parents and her brother to the cinema. It was at a young age, then, that she first saw Hollywood films in the theater, as well as films by the Shaw Brothers, Bruce Lee, and even King Hu.

I asked my mom if she had memories of seeing King Hu's *Dragon Inn*. She would have been sixteen at the time it premiered. She remembers the bike messengers who shuttled celluloid prints of popular films across town from one theater to another, as all of them shared the same reel (print traffic, literally). She recalls lines at the box office to see *Dragon Inn*; the buzz hailed it as a new kind of film. What was so singular about King Hu's films, she explained, was how the filmmaker made use of the natural landscape. The costume, hair, and make-up choices were also modern and singular—most notably the villainous eunuch's hair, dyed an orange color. But in its apparent skirting of historical accuracy, Hu's mise-en-scène broke from the established cinematic vernacular of martial arts films and depicted something else, something even more epic in scale. In my mother's words, King Hu broke out of the tradition of filming the *wuxia* genre on sets and took it outside, into natural landscapes that recalled the settings of Chinese handscroll paintings. Shooting in Taiwan, and later in Korea, King Hu re-created *wuxia* epics in exile—a kind of

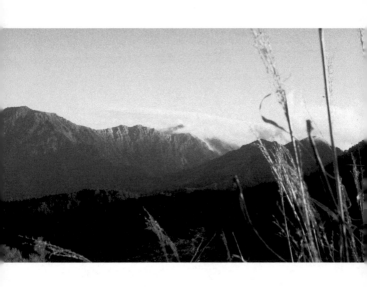

This page and previous page:
Tiffany Sia, stills from *The Sojourn*,
2023.

handmade cinema par excellence that would define the standard for Sinophone martial arts and action films for decades to come.

Born in Beijing, King Hu was sent as a child to live in Hong Kong as his family prepared to face persecution by the state for their foreign political ties. Though they were wealthy, his family had lower social status because they were part of the second concubine's line in the family hierarchy; therefore, his parents' priority was to protect their only son. In his premodern films, such as 1971's *A Touch of Zen*, King Hu reconstructed his birthplace, Beijing, which he'd left as a child and could no longer return to, reflecting on an old world that resided in the recesses of his memory. He brought to life quintessential *shan shui* landscapes (characterized by motifs of mountain and water) as exilic vistas that were made at a distance from the original place. In the 2022 films *The King of Wuxia Part 1: The Prophet Was Once Here* and *The King of Wuxia Part 2: The Heartbroken Man on the Horizon*, Taiwanese filmmaker Lin Jing-Jie explores the connections between King Hu's films and his biography. In *A Touch of Zen*, King Hu reconstructed the domestic *siheyuan* settings he grew up in. In *Dragon Inn*, the children of an executed Minister of Defense flee to the outlying territories and are pursued by an army of eunuchs—a story that mirrors his own exile from Beijing as a child. Part spy film, part Western, *Dragon Inn* and Hu's other films reflect imaginaries of an

imperial China that no longer existed, and offer up a fictive version of this bygone premodern era. King Hu's cinematic re-creations—his personal memories of an old life and an old world—were indirectly confrontational. Each of his films subtly wove the political into a *wuxia* epic, commenting on contemporary power struggles and decades of successive revolution in China.

* * *

Hong Kong appears again, this time as a critical location for exilic print. In her book of collected essays, *Yangtze! Yangtze!*, Dai Qing recalls that in the fall of 1988, she was invited to a conference in Hong Kong that gathered writers, journalists, and scholars from China and Taiwan whom she refers to as "cultural celebrities." An announcement that construction on the Three Gorges Dam was set to begin the following year was widely reported by Hong Kong media at the time of the conference, and criticism of the project ensued. Dai Qing's sojourn in Hong Kong inspired her to assemble the book, which comprises essays, analyses, and interviews with prominent Chinese intellectuals, experts, and politicians who opposed the massive state project to dam the Yangtze River. Denouncing the Three Gorges Dam for environmental and social reasons, the book chronicles issues ranging from the technical to the social: from engineering, sedimentation,

and flood control to community displacement, environmental concerns, and government funding. In *Yangtze! Yangtze!*, voices for social and environmental justice rose up alongside broader calls for reform, which coalesced in the student and worker movement of 1989. These voices warned of catastrophe, speaking out in an effort to prevent the mistakes of the past from being repeated,[19] and predicting that the dam would cause catastrophic climate damage, displace many residents, and create a large number of refugees. Dai Qing writes in the afterword, almost apologetically, "It's not difficult to tell that this book was compiled in a hurry."[20] Released in the spring of 1989, *Yangtze! Yangtze!* was published as the State Planning Commission convened to discuss the infrastructure project; public opinion reflected favorably on the book, which was described as bringing together many "ordinary people who became concerned with the Three Gorges Project."[21]

Dai Qing took part in the student movement of 1989. Most notably, she made a speech at Tiananmen Square, warning the students that they should leave peacefully to avoid bloodshed; if they did not, she predicted, their occupation might lead to a catastrophic and violent crackdown that would set back the ongoing campaigns for reform. Following the events of Tiananmen Square, contributors to her book were accused of being "advocates in bourgeois liberalization," as stated in a letter to the Communist Party branch of the State

Planning Commission written by two members of the Leading Group for the Assessment of the Three Gorges Project. "The interviewers and authors of the book, along with the journalists who reported on it," writes Xiao Rong—a former journalist at the literary and arts newspaper *Wenyi Bao*—in his essay in the book, "were all subject to examination and punishment. The voices of opposition were viciously suppressed." *Yangtze! Yangtze!* was de facto banned in a resolution that "accused the book of launching a political attack under the guise of scholarly debate."[22] Thirty thousand copies were subsequently recalled and destroyed. Twenty-five thousand copies that had been sold before the ban continued to circulate in China in surprising ways—including copies "displayed openly on the shelves of bookstores at the entrance to the auditorium of the Chinese People's Political Consultative Conference during its annual meeting."[23] Dai Qing was imprisoned following the student and worker protests.

The Three Gorges Dam was completed in 2003. Today, you can take a river cruise that sets sail from Hong Kong to the Yangtze to marvel at the dam, a popular destination for tourists and travel bloggers. *Yangtze! Yangtze!* lived on in its Hong Kong and Taiwan editions, and was translated into English by Nancy Liu, Wu Mei, Sun Yougeng, and Zhang Xiaogang. All editions of the book are now out of print. My own copy was published in 1994,

and has a stamp indicating it belonged to the library of the French Centre for Research on Contemporary China (La bibliothèque du CEFC); I found it in the used section at Bleak House Books in Hong Kong, a bookstore formerly located in San Po Kong, a largely industrial area. I bought the book during one of my last visits there. When the bookstore closed in 2021, its owner, Albert Wan, wrote in a blog post that he had decided to leave Hong Kong with his family. "The backdrop of these developments is, of course, politics," he explained.[24] Bleak House Books has since relocated to Honeoye Falls, New York.

* * *

Achille Mbembe describes being born *somewhere, anywhere* as an accident—an accident that can overdetermine an individual's politics, legal status, or identity. "How can who we are, how we are perceived, and how others take us, come to be indicated, and so irrevocably, by this accident?" he reflects.[25] To call a birthplace an "accident" is to conceive of it as neither fated nor destined, whereas labeling it as anything other than mere fact might dangerously attribute greater significance to, or produce fantasies about birthplace that give way to ethical troubles, like violent ethnonationalism. As Mbembe asks:

Why does this accident so decisively determine not only what we have rights to but also everything else, that is, the sum of proofs, documents, and justifications we are always obliged to supply if we are to hope for anything in the slightest, starting with the right to exist. . . .[26]

Mbembe goes on to offer the figure of the passerby as an post-humanist subject who resists easy co-optation into violence and the necropolitics of nation-states, proposing a counter-ethics to place. The passerby is a subject of ongoing transfiguration. Although Mbembe does not make the claim that transfiguration offers liberation outright, the conception of identity as an open-ended process carves out an ontological exit from a fixed place, undoing the fantasy that we might be redeemed by the search for our roots. There is no place to return to.

Perhaps the ethics of place lies in Trinh T. Minh-ha's description: "In assuming we know all about our own cultures, we often take for granted that being an insider entitles us to speaking and asserting meaning with authority. . . . Knowledge in its ready-made assertions makes it very difficult to come back to a place of beginner's wonder."[27] She asks, "But how to become a stranger in your own culture, your own territory, your own home?"[28] And what if you were a stranger to your own culture, your own territory, your own home all along?

* * *

I never met my grandfather, but I think of him often when I write. He had a nightly routine, as my mom tells it: after dinner, he would take a bath, and—dressed in a fresh white sleeveless shirt—sit in the living room to read from an English dictionary. Slowly, each night, he methodically turned a page. When I call up this image of him in my mind, I think of the humidity of the room in the North Point walk-up, the thin pages of the large dictionary, like a Bible's, wilting in the wet heat. After enduring two years[29] of covert psychological torture and nightly sleep-deprivation tactics implemented by the Chinese Communist Party, my grandfather had developed a stomach ulcer that never fully healed. His stomach lining was so badly damaged from the hyperproduction of acid during those stressful years that he constantly found blood in his stool. This haunted him for decades, up until his death. In his unpublished memoir, on the night before he passed, my father wrote: "I went to the hospital and found my father deep in sleep. The hospital explained to me that in the night my father started to scream, and they gave him a tranquilizer. He fell asleep then, and never woke up."

When my father's family adopted him, he was a thin and malnourished baby. My grandfather obtained powdered milk through the black market in Shanghai. It was 1949, a moment when, I imagine,

183 A Blurred Conceit

this would have been quite difficult, but not impossible thanks to his important political connections. In my father's account, my grandfather was a communist sympathizer. My father has long struggled with this, and as I attempt to understand my grandfather's legacy from what I can piece together on the page, the reading I derive from my father's words is my own, but deviates from my family's. My grandfather understood and sympathized with the aims of the communists, but in the messy tangle of civil war, he chose to remain neutral, refusing to commit to either the Chinese Communist Party or the Kuomintang Nationalist Party. In his memoir, my father recounts a story about my grandfather, which he only heard years later as told by my grandmother:

> During his youth when he was a student in Xiamen, many of his classmates were communists. In those days, they were all underground communists and once [. . .] they were found out, they would be executed. It was in one of those occasions when one of the students was executed by the nationalist army, they were waiting for the person to come forward to claim the body and knowing that it was a risky task. My father came forward to claim the dead body and arranged to send it back to the family in another region in the country for the burial. The nationalists

[knew] that he was neutral and they allowed him to come forward to claim. My father became the hero among his peers.

As a figure in my personal narrative, my grandfather resides alongside the other historical figures I write about for the screen. Here, my grandfather's position should not be misconstrued as passive; instead, it is defined by a troubled ambivalence and resistance to the political binarism that emerged during a time of revolution. And yet, it is hard to describe this position without his words, and with only my father's as context. I wonder where my father might find language to redeem him, where he obscures certain facts, what he wrestles with. "My father was cremated," he reflects, "as he was perhaps a fan of doctrine of the communists."

Given my family history, these figures call out to be attended to, perhaps even adjudicated. Writing about family might invoke a sentimental register, but I wonder about just letting their stories sit on the page, unresolved and restless. Following Mekas, and Ed's writings on him, it is perhaps the elsewhere sites of the global Cold War that offer history's most radically inconvenient lessons. The elsewhere isn't just the faraway; criticality toward a politics of the elsewhere resides precisely in the interstices of empire, between the poles of power that upend our fantasies of revolution or ideology. People who survive these stories offer anecdotal

dilemmas that may not be easily resolved by the national consensus of historical narrative.

When he exiled himself from Shanghai in 1956, my grandfather bought two gold bars to pay for his passage to Hong Kong, a first port of asylum. Years later, he would reunite with his family once my grandmother was able to find a way out through her connections to the founding members of the CCP, spending her dowry along the way. It was my grandfather who planted the idea in my father's mind that Hong Kong was only a temporary place, and that the transformation besieging Shanghai would inevitably encroach on Hong Kong, too. My father heeded this warning, sending me to the US as a child. "Father, I have followed your advice," my father wrote, addressing him directly in his memoir. Soon he switched back to the third person: "That was my father, a person I was only able to observe and never have a conversation with."

<center>* * *</center>

Historically, Hong Kong has played an important role as a refuge for film and print materials in exile. The city is mentioned in Thy Phu's *Warring Visions: Photography and Vietnam* as a crucial site in the critical afterlife of exilic images: Hong Kong was the port through which cameras were imported to Vietnam from Germany and the USSR, "presumably along the same routes traveled by Soviet-made

weapons."[30] During the Vietnam War, images from the Viet Cong were published and circulated throughout Hong Kong to counteract the influence of American photography, then "wired outside the country in a process that was so expensive, time-consuming, and unreliable . . . wire services during the war were spotty even for the Associated Press, never mind for Hanoi media agencies with limited access to key resources"—a supply chain of images that led to the development of what Thy Phu calls "socialist ways of seeing."[31] "Visual counternarratives require alternative archives," she observes, "resources that are not easily accessible or interpretable."[32]

In *Warring Visions*, Thy Phu expresses surprise, again and again, to come across Hong Kong so often in her research. Hong Kong is where *Vietnam in Flames* (*Việt Nam Khói Lửa*) was published. Remarking on the "only surviving official visual record of the fallen Saigon regime,"[33] Thy Phu describes how, in 1968, "Nguyễn Mạnh Đan and Nguyễn Ngọc Hạnh[34] documented the course of the war and its toll on soldiers and civilians in South Vietnam, including their own coverage of the Tet Offensive and its aftermath in a book published by the Government of Vietnam and printed in Hong Kong, a site selected likely because of scarce local resources."[35] Comparing it with her own hard-sought copy of the rare book, she examines a contraband copy of *Vietnam in Flames* owned by a collector whom she anonymizes, realizing that "a photograph of the flag

of South Vietnam, whose display the state still forbids, was missing from one of the front pages. If I had not studied my own copy of the book, I would not have suspected the surgically precise excision."[36] Several questions, for her, remained: Why was the book published in Hong Kong? How were its images selected? What was the book's intent?[37]

Though *Warring Visions* deals with images that live on, that demand to be circulated more globally or survive in clandestine collections, Thy Phu's study also contends with images that are irretrievable and lost. In the course of fleeing Vietnam, whole family archives disappeared; a vernacular visual history depicting the ordinary, everyday life of Vietnamese refugees before their exile vanished. Some of this visual history led Thy Phu to the amateur photographer Mrs. Luong Lu-Thai, who had managed to escape with her family to Hong Kong. From a refugee hotel, Mrs. Luong wrote to her parents, who were still in Vietnam, "implor[ing] them to arrange a safe passage for her albums also."[38] Tragically, her parents did not survive the journey, but "in a bitter twist, Mrs. Luong was reunited with her precious photos at around the same time she realized that she had become orphaned."[39]

❊ ❊ ❊

My studio mate Alex Nguyen-Vo, whose father is from North Vietnam and whose mother is from

South Vietnam, told me his father spent almost a year in one of the Hong Kong refugee centers. During his residency at Speculative Place, an art space I ran out of a rented house on Lamma Island from 2018 to 2021, Alex had originally intended to research this fraught family history as he worked on a new body of paintings. We could not have predicted that his arrival in August 2019 would coincide with the moment the protests reached a fever pitch. He sat next to me as I processed and watched the 8/31 incident on a live stream; he watched me write lawyers' numbers on my arm before boarding the Lamma ferry every morning to volunteer. He appears in my film *Never Rest/Unrest*. Speculative Place wasn't run in any official capacity; the residents received free room and board, but the residency wasn't officially registered as an LLC or an organization. It was just a name and a website, paid for with extra money my husband and I pulled together from our day jobs. Because of the ad hoc nature of the program, residents were often already collaborators of ours, or were invited through referrals, and the ethos was of cohabitating and building something slightly off the beaten path of art spaces. On a practical level, for liability reasons, the project could not scale up; this became extremely clear during the protests. When it came to safety, all I could do was talk to Alex about what he felt was bearable.

189 A Blurred Conceit

* * *

I'd thought about making this last essay a manifesto—or even a handbook on how to work with anonymous collectives and artists who make politically sensitive work—but in the end, I settled on writing about writing, writing about reading—writing around and within and outside of things, writing on close and distant studies. I figured if the reader had made it this far, unhindered by my many attempts to thwart the inattentive, or deter the bored state agent who was given the unfortunate assignment of trawling this text for sensational or incriminating details, then I would bury my most obtuse lessons yet here, at the end. I hope I have lost at least the agent by now.

* * *

Months ahead of my trip to Taiwan to shoot my short film *The Sojourn*, repetitive yet often vague warmongering news concerning the country was circulating. "Taiwan Prepares to Be Invaded," read one headline in the *Atlantic*.[40] News cycles fluttered in and out of view on my news feed for weeks on end, along with comments and threads that tried to read the military activity in the Taiwan Strait and the South China Sea like tea leaves spinning in the water. These fearful headlines were so indefinite and shapeless that I didn't bother to ask my friend

Timmy Chih-Ting Chen, a Taiwanese scholar and writer, his thoughts. We were planning to meet in Taiwan for my shoot; he would fly from Hong Kong, where he was teaching. I imagined any question that tried to assess the true state of the situation—like what he thought of the threats and whether they were material—would not only be routine for many Taiwanese people, but also unanswerable and tedious. Besides, Timmy seemed most worried about rain in the days leading up to the trip. *The weather in Taiwan seems to be bad*, he texted me one evening. *Constant rain*. I texted back, partly to set my own mind at ease, too: *I think rain or shine, contingency is a critical part of the piece. Distortion, memory, fantasy.*

I was planning to shoot a landscape film in the locations where King Hu shot *Dragon Inn*. Interested in the relationship between cinema and scrolls, I was initially drawn to revisiting King Hu's work after a 2021 conversation with Tammy Cheung, the Hong Kong documentary filmmaker. Tammy had left the city to move to the UK around the same time I left Hong Kong to return to the United States; she had taught many documentary film-makers in Hong Kong and founded the film distribution company Visible Record, which ran the Chinese Documentary Festival, an important venue where risky political films from mainland China were shown.[41] Tammy described King Hu as her favorite director. King Hu, she argued—and I hope

I am paraphrasing from memory well—is a singular filmmaker who breaks from the dead ends of cinema as a medium of Western origins. He was able to establish a cinematic vernacular that was distinctly Chinese in aesthetic, harking back to premodern scrolls and their landscape compositions. While I am reluctant to embrace any kind of essentialism around cultural definitions, the formal marriage Hu achieves between scrolls and cinema is compelling. I was drawn to his reflections on premodern paper form, the translation of scrolls into celluloid. Continuous perspectival planes are parsed both in viewing the scroll and in watching the long cinematic take. Such a marriage of premodern and contemporary forms also highlights the scroll's capacity to express duration, to perform a pictorial trick that unites many perspectives into a single ongoing and unfurling scene.

Just before Thanksgiving, Timmy texted me over Telegram: *I talked to the protagonist in Dragon Inn, [Shih Chun]. He is willing to help you with your project. I bumped into him after the end of the Golden Horse award ceremony—it's destiny.* When I arrived in Taipei, Timmy, Andrew, and I met Shih Chun at a Din Tai Fung location in the Zhongzheng District; he arrived to lunch wearing a black Adidas baseball cap, a checkered button-down shirt, and a rain jacket. It had been raining for ten consecutive days in Taiwan, he said. I was worried about the shoot and had hoped it would clear by now.

This page and previous page:
Tiffany Sia, stills from *The Sojourn*,
2023.

He advised us on the best routes to take to the locations where *Dragon Inn* was filmed, warning against traveling along the eastern coast due to rockslides. We should take the longer route, he said, along the west coast. Recalling even the time of day that King Hu had watched for the mist, he noted that near sunset, after four o'clock in the afternoon, is when the mist begins to climb the mountain.

Driving up through the skirts and peaks of Hehuanshan in a small Japanese rental car, Andrew and I attempted to trace King Hu's steps. We made the journey several times over multiple days, first on a reconnaissance trip, taking the route along the eastern coast. It was gray that first day, after so many consecutive days of rain, and for most of the drive we pushed through thick, wet fog. It wasn't until we made it through the tunnel of Dayuling that we saw bursts of sunlight break, as if we had driven above and beyond the clouds sitting ten thousand feet above sea level. We captured the most mist on that first day; upon the appearance of a pink sunset, we caught the billowing haze move over a mountain range—as in the landscape images I had studied in *Dragon Inn*, as well as the ink scrolls in the National Palace Museum, which King Hu frequented for inspiration. The conditions finally seemed perfect after all the rain; the precipitation still hung in the air.

Afterward, I experienced altitude sickness, which felt like a bad hangover, and had to rest

following each day of filming. We drove back out to shoot for a few more days, during which we encountered only completely clear skies and struggled to get a shot like the first. Timmy arranged for us to meet with Indigenous filmmaker Pilin Yapu of the Atayal tribe, who was also the principal of the first Indigenous school in Taiwan, P'uma Elementary School in Taichung. He told us about their experimental curriculum, part of the state public school system, in which the children are taught the Atayal language, English, and Mandarin, as well as spearfishing and mouth harp. We spent the whole afternoon with Pilin Yapu and the teachers at his school; he showed us some of the short films he had shot there and generously took us out to lunch. He and his teachers explained Tayal legends and demonstrated the mouth harp. Also called the *lubuw*, the instrument is made of bamboo, with open grooves on the inside that produce different pitches through the action of pulling a string. The sound from the *lubuw* moves through the musician's mouth, held open just so, creating a reverberation and distinctive timbre.

Weaving through the mountainous landscapes of Taichung, we ended up staying at a business hotel in Taicheng after a day of shooting in Miaoli. Rather than return to Taipei, we headed five hours south to Kaohsiung to pick up Tiff Rekem, my videographer, for the final day of shooting on the mountain. We started the journey at four in the morning,

hoping the dawn precipitation would cling to the air and give way to mist. It ended up being another clear day. After several hours, as we snaked around the mountain roads searching for mist, we decided to drive back down the mountain before lunch. At its base we glimpsed a large plume of white smoke, as if announcing itself finally in front of a mountain view, then realized it was a large pile of leaves and wood on fire. We spent an additional day shooting elsewhere at Xiao Wulai Waterfall, a scenic overlook in Atayal land (the Mandarin word *wulai* is a transliteration of the Atayal word *ulay*, referring to the volcanic hot springs there). Then we all drove back up to Taipei just in time for Christmas. The multiple days of shooting at high altitude had given me a head cold, and Andrew and I ate Christmas dinner in the hotel room. Catching up on the news, we read reports of China's "largest incursion yet to the air defence zone" in Taiwan.[42]

During my remaining days in Taiwan, Timmy and I managed to squeeze in a few more meetings. We met with Taiwanese filmmaker Lin Jing-Jie, the director of the recent biopic films on King Hu, who shared stories about Hu's life and work for hours until the sun went down. Timmy and I had a final lunch with Shih Chun. I told him that, after many attempts, it was incredibly difficult to re-create the landscape scenes that King Hu had shot. I had wrestled with the weather and struggled to find the "perfect" atmospheric conditions; how

did King Hu accomplish this with a whole cast and crew? Driving through these landscapes gave me an even greater sense of the practical challenges of creating his ink-scroll-painting-inspired landscapes, which he brought to life in CinemaScope. Timmy and I also shared with him our brief visit to the Indigenous school, and how such an experience only multiplied the many political meanings entangled in a landscape film, specifically in the historical context of Taiwan. Indigenous presence and *wuxia* imaginary are paradoxically co-present in a landscape image.

Shih Chun suggested I return to Taiwan to make another work on King Hu; if I spent more time there, he would dedicate himself fully to my project. He told us about the last film Hu planned to make, *Battle of Ono*, which was never completed. It was to be shot in the United States and would focus on the Chinese coolies who worked on the transcontinental railroad. Getting the project off the ground took years. King Hu spent the last decade of his life in California, all his energy devoted to developing and financing this project. A script had been completed, funding secured, and casting had even begun (Chow Yun-fat was confirmed for the project), but King Hu died of complications related to heart surgery just before the project began shooting. Director John Woo, who had long looked up to King Hu as a master of the form and had begun in the industry as an extra in one of Hu's

films, covered the cost of Hu's grave plot. In an unexpected geographical twist, King Hu is buried in Rose Hills Memorial Park in Whittier, California, just outside of Los Angeles.

<center>❖ ❖ ❖</center>

There is another part of my father's unpublished memoir that stands out to me; in it, he reflects on the month leading up to the Tiananmen Square massacre. He was in Beijing for a visit, along with my mother, helping a friend of his who was in mourning. He describes seeing the students at Tiananmen Square:

> When we landed there it was during the last week of May of 1989. Beijing's atmosphere was very tense because of the students' movement calling for anti-corruption. The main boulevard, in the capital, Chang'an Avenue was blocked for one side, it was four lanes in each direction, and one side was blocked for rally by the workers and the students to demonstrate their discontent. I was downhearted as I could sense the trouble and with my camera, I wasn't taking any pictures that were relating to this sensitive situation.
>
> We went to every palace and visited the Great Wall and even the Ming Tomb as planned. Later we found that CNN and the

camera teams were also checking into our hotels, the Sheraton Great Wall, and saw their unloading of the heavy equipment for covering the news of Gorbachev's visit in Beijing. The Forbidden City was surrounded by the students blocking his visit and it also affected the visiting plans. I recalled that when Gorbachev left, he commented at the airport saying that the Chinese would need to solve their students' movement quickly.

This part about my parents' sojourn in Beijing did not make it into my father's final draft; I had to sift through old emails to find it.

Following the massacre, my parents brought me along when they marched in a procession through Hong Kong Island, in solidarity with a million and a half others. This would have been a week after I turned a year old. In our personal family photo archives, the camera has captured only certain moments in our lives: gatherings where my mother's large family is posed against a red satin restaurant backdrop; scenes of travel and visiting tourist destinations and paying my aunt a visit in New York; a series of photos of my parents taking pictures of each other during their teenage courtship, when they visited the scenic overlook of Victoria Peak in Hong Kong. There is another image, the most candid and intimate, taken of them embracing—their reflected image captured in a mirror. Yet many of the stories I've been told could

never be gleaned from these photographs of tourism, of togetherness. The partial memory we recollect through photographs only underscores a suspicion I have of the medium: that photographic or filmic images are in crucial alliance with the invisible. What is unsaid or unseen defies capture, importantly. Within a collection of photographs, whether public or private, what is not shown or said often comprises the most essential and also the most potent material. In our family photos, there are no images of Shanghai. It is as Trinh T. Minh-ha describes:

> Truth never yields itself in anything said or shown. One cannot just point a camera at it to catch it: the very effort to do so will kill it. It is worth quoting here again Walter Benjamin for whom, "nothing is poorer than a truth expressed as it was thought." Truth can only be approached indirectly if one does not want to lose it and find oneself hanging on to a dead, empty skin. Even when the indirect has to take refuge in the very figures of the direct, it continues to defy the closure of a direct reading.[43]

* * *

As an undergrad, I would search for "Hong Kong" in the college library, scrolling through JSTOR articles and paging through books. I recall a slim

section of maybe half a dozen titles vividly and with great tactile memory; the volumes were housed on the third floor of the library. It was there that I discovered Ackbar Abbas and Rey Chow. I became enthralled with their work—even more than I did with Wong Kar-wai, or, later, Tsai Ming-liang and Hou Hsiao-hsien—and through it, I began to see film studies as a way to enliven so much more about cinema than cinema itself, as a way to encounter history and return to the original place anew. At some point I read about Iguazu Falls in Wong Kar-wai's *Happy Together* as an abyss of desire— an orifice. A void into which to confess your longing. Ultimately, though, it was a distant and elusive place of togetherness.[44]

*　*　*

King Hu constructed a makeshift device to create the appearance of mist in his films, tying grass and twigs together in a barrel punctured with holes. Once lit, the air would move through the device, lifting the white smoke and permeating the frame. Smoke was essential to filling a scene with a sense of enchantment in King Hu's *wuxia* imaginary, making it appear out of time. It is a paradox at the center of the image: meticulous care is poured into every detail of a scene, only to be partly obscured by smoke or mist—engulfed in a kind of white space, an exhale, on-screen.

Recently Timmy texted me: *Shih Chun said hello to you, asking when you will return.*

Notes

1. K Street, in downtown Washington, DC, is a street where many lobbyists, lawyers, and advocacy groups are based.

2. Ed Halter, "Jonas Mekas, Life Itself," in *Jonas Mekas: The Camera Was Always Running*, ed. Inesa Brašiškė, Lukas Brasiskis, and Kelly Taxter (New Haven: Yale University Press, 2021), 134.

3. Halter, 134.

4. Michael Warner, *Publics and Counterpublics* (New York: Zone Books, 2002), 9.

5. Warner, 11.

6. See Hazel Clark and David Brody, eds., *Design Studies: A Reader* (London: Bloomsbury Visual Arts, 2022).

7. James Baldwin, "Nothing Personal," in Richard Avedon, *Nothing Personal* (New York: Dell Publishing Company, 1964), n.p.

8. I've made mention of this passage in my chapbook *Salty Wet* ("Do you ever wonder who James Baldwin fell in love with in Hong Kong when he wrote this?"), but could never figure out how to incorporate it into a text until now.

9. Magdalena J. Zaborowska, *James Baldwin's Turkish Decade: Erotics of Exile* (Durham, NC: Duke University Press, 2009), xxi.

10. Baldwin, "Nothing Personal," n.p.

11. James Baldwin, "The New Lost Generation," 1961; quoted in Zaborowska, *James Baldwin's Turkish Decade*, xxi.

12. "Elliptical Returns" originally appeared in the Summer 2023 issue of *Film Quarterly* as "New Territories: Reconfiguring Publics in Former and New Hong Kong Cinema."

13. There was something I liked about the juxtaposition of Baldwin and Snowden that I couldn't quite put my finger on at the time; this idea about "odd bedfellows" later became clearer. In retrospect, the whole essay may be about odd political bedfellows in a time of revolution.

14. Fadi A. Bardawil, *Revolution and Disenchantment: Arab Marxism and the Binds of Emancipation* (Durham, NC: Duke University Press, 2020), xvi.

15. Bardawil, xvii.

16. Bardawil, xv.

17. A thirty-eight-year-long period of martial law imposed by the Taiwanese government, characterized by campaigns of torture, imprisonment, and execution of political enemies of the state.

18. These stories of family and ghosts are referenced in my film *What Rules the Invisible* (2022).

19. This kind of warning—to learn from history and past mistakes—stems from Dai Qing's own complicated background. She had been a member of the Chinese Communist Party, one of its idealists, and began her political career as a spy. But when she began to disagree with the CCP, she became their target. In some parts of the English edition of *Yangtze! Yangtze!*, Dai Qing alludes to her mother having also been subject to surveillance or intimidation tactics by the CCP. A footnote helps clarify important personal facts that Dai otherwise only hints at: "Although a committed communist, her mother suffered at the hands of the Party for pursuing issues such as the Three Gorges dam that challenged the Chinese Communist Party."

20. Dai Qing, *Yangtze! Yangtze!*, ed. Patricia Adams and John Thibodeau, trans. Nancy Liu, Wu Mei, Sun Yougeng, and Zhang Xiaogang (London: Earthscan, 1994), 262.

21. Qing, 14.

22. Xiao Rong, "The Banning of Yangtze! Yangtze!," in Qing, *Yangtze!*, 20.

23. Rong, in Qing, 21.

24. Quoted in Tom Grundy, "Hong Kong Independent Bookstore Bleak House Books to Close," *Hong Kong Free Press*, August 29, 2021, hongkongfp.com /2021/08/29/hong-kong-independent -bookstore-bleak-house-books-to-close.

25. Achille Mbembe, *Necropolitics* (Durham, NC: Duke University Press, 2019), 185.

26. Mbembe, 186.

27. Trinh T. Minh-ha, "'There Is No Such Thing as Documentary': An Interview with Trinh T. Minh-ha," interview with Erika Balsom, *Frieze*, November 1, 2018, frieze.com/article/there-no-such-thing-documentary-interview-trinh-t-minh-ha.

28. Trinh, "No Such Thing."

29. The exact period of time is unclear and distorted by my father's childhood recollections. His original journal describes two years. However, another, more recent piece of writing notes several weeks.

30. Thy Phu, *Warring Visions: Photography and Vietnam* (Durham, NC: Duke University Press, 2022), 68.

31. Thy Phu uses this phrase throughout *Warring Visions*, but especially in Part I: Socialist Ways of Seeing Vietnam, 56–145.

32. Thy, *Warring Visions*, 49.

33. Thy, 19.

34. Of these two Vietnamese diaspora photographers, Thy writes further that many knew the "eminent Nguyễn Mạnh Đan, but only a few admit they have heard of Nguyễn Ngọc Hạnh, who, because he served as an ARVN [Army of the Republic of Vietnam] officer, was sentenced to a labor camp, where he spent eight years before a human rights organization secured his release and eventual resettlement in the United States." Thy, 23.

35. Thy, 46.

36. Thy, 50.

37. Thy, 23.

38. Thy, 182.

39. Thy, 182.

40. Ben Rhodes, "Taiwan Prepares to Be Invaded," *Atlantic*, November 7, 2022, theatlantic.com/magazine/archive/2022/12/china-takeover-taiwan-xi-tsai-ing-wen-671895/.

41. Mette Hjort, whose work I cite in "Elliptical Returns" (p. 85), mentions Tammy Cheung in the book *Film and Risk* while discussing the work of filmmaker Ai Xiaoming. Hjort writes: "Ai Xiaoming is a filmmaker who is constantly on the government's radar and who has had to keep a very low profile from time to time. In 2009, for example, she was to have attended the Chinese Documentary Film Festival organized by Tammy Cheung and Visible Record in Hong Kong but was prevented from doing so on account of the risks to which her film about the Sichuan earthquake had exposed her, and her need as a result to be out of the public eye for a while." Mette Hjort, "Flamboyant Risk Taking: Why Some Filmmakers Embrace Avoidable and Excessive Risks," in *Film and Risk*, ed. Mette Hjort (Detroit, MI: Wayne State University Press, 2012), 51.

42. Yimou Lee, "Taiwan Reports China's Largest Incursion Yet to Air Defence Zone," Reuters, December 26, 2022, reuters.com/world/china/taiwan-says-43-chinese-air-force-planes-crossed-taiwan-strait-median-line-2022-12-26/.

43. Trinh T. Minh-ha, in Nancy N. Chen, "'Speaking Nearby': A Conversation with Trinh T. Minh-ha," *Visual Anthropology Review* 8, no. 1 (March 1992): 86.

44. Years later, I had lunch with Jean Ma after giving a lecture to her class at Stanford, where I showed a rough cut of *The Sojourn*. In telling her about my circuitous journey to the field of Hong Kong studies, I learned that, when she taught at Bard, she had ordered the books by Abbas and Chow I'd found in Stevenson Library.

Acknowledgments

I would like to express my heartfelt gratitude to Primary Information for providing me with the incredible opportunity to publish my first collection of essays. This would not have been possible without the unwavering support, vision, and dedication of James Hoff and Matthew Walker. Your belief in my work and your commitment to supporting artists' books and writings is profoundly seen and appreciated—and has served over the years as a big inspiration for my practice. For this to come full circle is a dream come true for me.

I also want to extend my sincere thanks to Rachel Valinsky and Bryce Wilner for their invaluable contributions to this project. Rachel, your meticulous editing and keen insights have helped shape my essays into their best possible form. Every step of the way, you have supported my ambitions for the texts and helped to retain my voice. Bryce, your design work has allowed my collection of essays to come to life visually and has provided an inspiring structure to write alongside. Thank you also to Allison Dubinsky for the precise and invaluable technical edits. All your close partnership and support have been instrumental in making this publication a reality.

I want to give a special thanks to Jean Ma, whose work has been an inspiration to me for over

a decade. I am ever grateful for your incredibly generous foreword. What a gift it was to work together in close proximity while across a great distance.

Thanks to Andrew Vaterlaus-Staby, my parents, and my in-laws, for their unwavering love and encouragement; and to Kimi, for her constant inspiration.

Lastly, I would like to acknowledge the following individuals, who have played significant roles in my journey: Aleesa Pitchamarn Alexander, Angie Baecker, Kay Beadman, Dena Beard, Thomas Beard, Emily Verla Bovino, Sekou Campbell, Sophie Cavoulacos, the Centre for Land Affairs, Chan Tze-Woon, Gordon H. Chang, Howie Chen, Timmy Chih-Ting Chen, Karin Chien, Shih Chun, Stella Cilman, Stuart Comer, Catherine Damman, Sjoerd Dijk, Onyx Fujii, Felix Gaudlitz, GHOST, Leo Goldsmith, Maxwell Graham, Niccolò Gravina, Matilde Guidelli-Guidi, Ed Halter, Hong Kong Documentary Filmmakers, Sky Hopinka, David Joselit, Haley Josephs, Joan Kee, Adam Khalil, Michelle Kuo, Marci Kwon, Carolyn Lazard, An-My Lê, Pamela M. Lee, Michael Leung, Simon Leung, Pavle Levi, Dennis Lim, Lin Jing-Jie, Almudena Escobar López, Jordan Lord, Shibani Mahtani, Timothy McLaughlin, Jessica Morgan, Alex Nguyen-Vo, Lakshmi Padmanabhan, Yuri Pattison, Rebecca Prime, B. Ruby Rich, Jay Sanders, Girish Shambu, Herb Shellenberger, Joshua Gen Solondz, Bayley Sweitzer, virgil b/g taylor (aka "fag tips"), Grace En-Yi Ting, tooth, Elvia Wilk, Peter Yam,

Jonathan Yu, and my colleagues at my day job, for their support.

I am profoundly grateful for your presence in my life. Your friendship, collaboration, and intellectual support have enriched and inspired my work and my life in immeasurable ways.

Tiffany Sia, 2024

On and Off-Screen Imaginaries
©2024 Tiffany Sia and Primary Information

ISBN: 979-8-9876249-7-5

Editor: Rachel Valinsky
Managing Editor: James Hoff
Designer: Bryce Wilner
Copy Editor: Allison Dubinsky

Primary Information
232 3rd St., #A113
The Old American Can Factory
Brooklyn, NY 11215
www.primaryinformation.org

"Handbook of Feelings" ©2022 *October* and
the Massachusetts Institute of Technology.
"Foreword" ©2023 Jean Ma.

An earlier version of "Handbook of
Feelings" was published in *October* 180
(Spring 2022). The essay is reprinted here
courtesy the MIT Press.

An earlier version of "Phantasms of
Dissent: Hong Kong's New Documentary
Vernacular" was published in *Film Quarterly*
75, no. 4 (Summer 2022): 34–46.

An earlier version of "Elliptical
Returns: Reconfiguring Publics in Former
and New Hong Kong Cinema," was published
as "New Territories: Reconfiguring Publics
in Former and New Hong Kong Cinema,"
in *Film Quarterly* 76, no. 4 (Summer 2023):
9–21.

Stills from *What Rules the Invisible* ©2022
Tiffany Sia. Courtesy the artist.

Stills from *The Sojourn* ©2023
Tiffany Sia. Courtesy the artist.

Untitled, Tien Phuong (1995); *Untitled,
Mekong Delta* (1994); *Rescue* (1999–2002); and
Sniper I (1999–2002) ©An-My Lê. Courtesy
the artist and Marian Goodman Gallery.

Stills from *Blue Island* ©2022 Chan
Tze-Woon. Courtesy Icarus Films.

Stills from *Inside the Red Brick Wall*
and *Taking Back the Legislature* ©2020 Hong
Kong Documentary Filmmakers. Courtesy
Icarus Films.

Printed by Grafiche Veneziane, Italy.

Primary Information would like to thank
Karin Chien, Matilde Guidelli-Guidi, David
Joselit, Pamela M. Lee, and B. Ruby Rich.

This publication is supported in part by the
National Endowment for the Arts.

Primary Information is a 501(c)(3) non-
profit organization founded in 2006 to publish
artists' books and writings. The organization's
programming advances the often-intertwined
relationship between artists' books and arts
activism, creating a platform for historically
marginalized artistic communities and practices.
Primary Information receives generous support
through grants from the Michael Asher
Foundation, Galerie Buchholz, the Patrick and
Aimee Butler Family Foundation, The Cowles
Charitable Trust, Empty Gallery, The Ford
Foundation, The Fox Aarons Foundation,
the Helen Frankenthaler Foundation, Further-
more: a program of the J. M. Kaplan Fund, the
Graham Foundation for Advanced Studies in
the Fine Arts, Greene Naftali, the Greenwich
Collection Ltd, the John W. and Clara C.
Higgins Foundation, Metabolic Studio, the
New York City Department of Cultural Affairs
in partnership with the City Council, the
New York State Council on the Arts with the
support of the Office of the Governor and
the New York State Legislature, the Orbit Fund,
the Stichting Egress Foundation, VIA Art Fund,
The Jacques Louis Vidal Charitable Fund,
The Andy Warhol Foundation for the Visual
Arts, the Wilhelm Family Foundation, and
individuals worldwide. Primary Information
receives support from the Arison Arts Foun-
dation, the Willem de Kooning Foundation,
the Marian Goodman Foundation, the Henry
Luce Foundation, and Teiger Foundation
through the Coalition of Small Arts NYC.

This page and previous page:
Tiffany Sia, stills from *The Sojourn*,
2023.